Master's Guide to
WEDDING PHOTOGRAPHY

Capturing Unforgettable Moments
and Lasting Impressions

Marcus Bell

AMHERST MEDIA, INC. ■ BUFFALO, NY

All rights reserved.
Published by:
Amherst Media®
P.O. Box 586
Buffalo, N.Y. 14226
Fax: 716-874-4508
www.AmherstMedia.com

Publisher: Craig Alesse
Senior Editor/Production Manager: Michelle Perkins
Assistant Editor: Barbara A. Lynch-Johnt

ISBN-13: 978-1-58428-197-9
Library of Congress Control Number: 2006930066
Printed in Korea.
10 9 8 7 6 5 4 3 2 1

TABLE OF CONTENTS

Marcus Bell is one of those rare finds. We've all had an experience where a friend says, "Oh, you've got to hear this new band," then you take a listen and have to admit it—they're fantastic. That's what it was like the first time I saw Marcus's work. A mutual friend told me to check out his web site, and I had the same reaction I had the first time I heard The Police (sorry, I'm dating myself): "Wow, this is unbelievable!" It's the real deal.

Marcus is not only good at wedding photojournalism, as we call it here in the United States, but he's a first-rate portraitist and an accomplished fine-art landscape photographer. It is very rare that one photographer, and especially one so young, can be so well versed in three distinctly different disciplines. It is no wonder he's proven to be a major award winner throughout the world.

I recently took a look at Marcus's list of awards, which is two full pages long and only goes back to 1999. I don't think I've ever seen such an impressive list, and he has only recently begun winning awards in America. But he is not about awards or celebrity. He is all about honesty and the human dynamic. Marcus seems to possess that rare ability to make a human connection on both sides of the camera and communicate feelings in some universal human language that cuts across cultural barriers.

His images also possess what art directors call "It." Many refer to "It" as impact, while others see it as style. I think the "It" that Marcus has is a combination of rare skills and personality traits. He connects with people readily and has the eye of a cinematographer, at once able to see the heart of a story, big or small, and present it within a framework of great design.

What is equally impressive about Marcus is his unabashed humility. He once told me, "I'm not really known for my portraits." Yet his portraits exhibit a kind of innocence and complexity that make one keep staring long after the information in the image has been digested. Marcus's pictures of people exhibit what people have called "the life force"—an effective glimpse into the soul.

I think Marcus Bell has many miles to go in his journey as an image maker and communicator. This book is just one small step in a lifetime that will produce some of the finest photographs we have ever seen.

—Bill Hurter
Editor, *Rangefinder* magazine

FOREWORD

*M*arcus is the owner and principal photographer of the successful boutique photography studio, Studio Impressions, which he has operated for over ten years. He is also an internationally recognized authority in photography. A respected speaker and member of the Wedding and Portrait Photographers International (WPPI) and the Australian Institute of Professional Photography (AIPP), he is considered a leader in his field. He has held titles for wedding, portrait, landscape, and editorial photography and has been awarded for his new approach for combining each discipline to create a distinctive brand of photography.

Marcus has written numerous articles for photography magazines and has been profiled by Australian and international magazines for his wedding, landscape, and portrait images. He has lectured in Australia, the United States, Japan, Canada, New Zealand, Ireland, Wales, Scotland, and England.

He has received his Master of Photography twice in Australia and in the United States, been honoured with a fellowship in the United Kingdom, served on the board of the AIPP, and received in excess of a hundred Australian and international awards for his photographic works since 1999. In 2006, Marcus and Studio Impressions were named the number-one wedding photographer and photography studio in Australia. The award was judged by a panel of fifty industry leaders who recognized the studio for its outstanding contribution to photography.

For further information, visit www.Marcus Bell.com and www.StudioImpressions.com.au. You can also e-mail Marcus at: Marcus@studioimpressions.com.au

AWARDS
- Australian Wedding Photographer of the Year
- Queensland Wedding Photographer of the Year
- Queensland Professional Photographer of the Year
- International Grand Premier Photographer of the Year
- International Wedding Photojournalism Photographer of the Year
- International Portrait Print of the Year
- International New Approach Award
- International Orivetio Italian Photographer Award
- Queensland Landscape Photographer of the Year
- Queensland Editorial Photographer of the Year
- Master of Photography—United States and Australia
- Fellow of Photography—United Kingdom
- Master Print Maker—(Qualified) Digital and Traditional Process
- Queensland Illustrative Photographer of the Year

To understand the history of wedding photography you need look no farther than your own family's images. Ask to see your parents', grandparents', or even great-grandparents' wedding images for a rundown on the history of popular wedding photography. In most cases, there will be very few images to see, as many couples married during the Depression could ill afford to employ a wedding photographer to capture their entire wedding and settled instead for a few posed portraits.

While there are some classic standouts, most of the images are stiff and lack any display of emotion. The images are usually yellowish, sometimes torn, or permanently attached to the glass in the very old frame. Rarely were the images presented in an album; those images that were presented in an album were typically attached to the pages using glued tags that have long since lost their adhesive qualities. Sometimes the images are scattered through different parts of the family and do not show the story of the wedding day. There was certainly some beautiful portraiture done of weddings, and the few wedding albums that exist are very classic in their structure.

One thing about past wedding photography remains the same today: it holds incredible sentimental value for the couple, their relatives, and friends. How wonderful is it to sit down with your siblings and look through images of your ancestors and hear stories about them? This is still the key to the runaway success of contemporary wedding photography. People want tangible reminders of their past, to remember those they love, and to capture the most meaningful days in their lives.

A SIMPLE PHILOSOPHY

Over the last ten years, I have stayed true to a simple philosophy that I wrote down when creating my first ever business plan. I wanted to have a studio that was in business for all the right reasons, and keeping to these basic ideals has helped me to accomplish this goal. The principles I use are as follows:

1. **Shoot from the Heart.** You are shooting for yourself as well as your clients.
2. **Build Relationships.** When your clients like and trust you, you'll be able to capture more genuine images.
3. **Communicate Your Vision into Print.** Produce fine-art master prints that truly reflect the emotion of the moment. Accomplishing this requires both technical expertise and refined artistic sensibilities.
4. **Be Remarkable.** Provide an outstanding experience every time. From your photography, to your products, to your customer service, you should always set out to be the very best.

By adhering to these principles, you can ensure a truly wonderful experience that will enable your client to connect not only with the images you have captured but also with you and your studio. The on-going rewards are too countless to mention, but some key benefits are:

1. Your clients will love and trust you.
2. They will want to own a beautiful story book of their wedding day.
3. The album and images will be cherished for generations to come.
4. You will create the best images you have ever shot and develop an incredible body of personal work.
5. Clients will return to your studio time after time.
6. Your clients will refer more business to you.

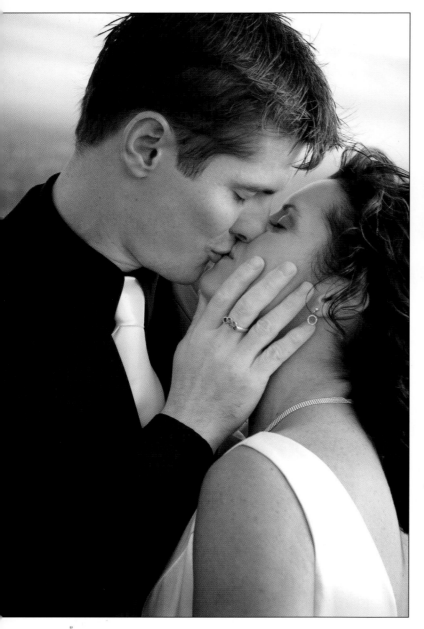

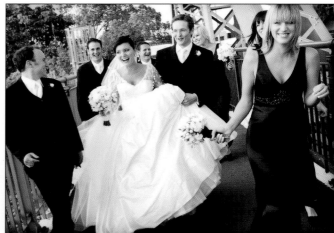

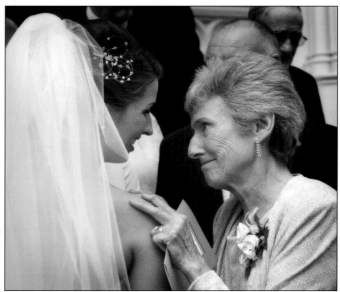

In today's wedding photography, emotion is a key element. People want tangible reminders of this most meaningful day and how it felt to be a part of it.

They want images that enable them to remember the words they shared and the emotions they felt.

It is an enormous responsibility for a wedding photographer to take on, and one that they must do their utmost to live up to. However, it is also a tremendous privilege for those of us who take on the challenge.

HOW WEDDING PHOTOGRAPHY HAS CHANGED

One of the most notable changes I have seen in wedding photography can be illustrated with a look at a single image. *La Stricte Intimite,* a photograph by Robert Doisneau depicting a just-married couple walking into a café while life continues on around them, is a wonderful example of the birth of contemporary wedding photog-

raphy, except that it was shot in 1945. An image like that could be part of many modern wedding photojournalists' portfolios, yet Doisneau was not a wedding photographer—just an outstanding photographer. (Doisneau was active around in the same era as the birth of the great Magnum photo agency that included photographers like Henri Cartier-Bresson and Elliott Erwitt.)

This kind of work was carried forth by photographers like David Oliver (in Australia) and Denis Reggie, who photographed the wedding of John Kennedy Jr. and Caroline Bissett. Newspapers around the world carried the iconic image of John Jr. kissing Caroline's hand as they exited the small island church, and this arguably marks the beginning of mass interest in photojournalis-

tic wedding images in the public's eye (although, in Australia, it had already been around for many years).

If you want to discover the current trends in wedding photography, simply pick up any bridal magazine and flip through the pages. Brides and grooms take their inspiration from these pages, and they are generally highly photojournalistic in their content, portraying real moments and emotions. Couples are bombarded with the documentary-style wedding images at every turn, and this is echoing through the photographic industry.

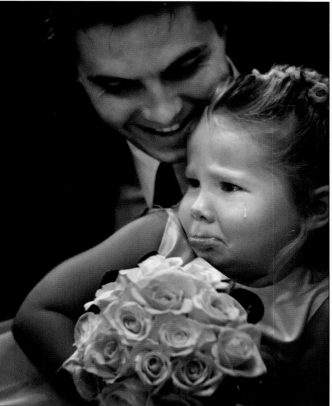

Today's wedding albums typically include a combination of posed images and more spontaneous documentary images.

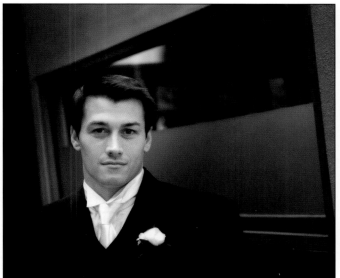

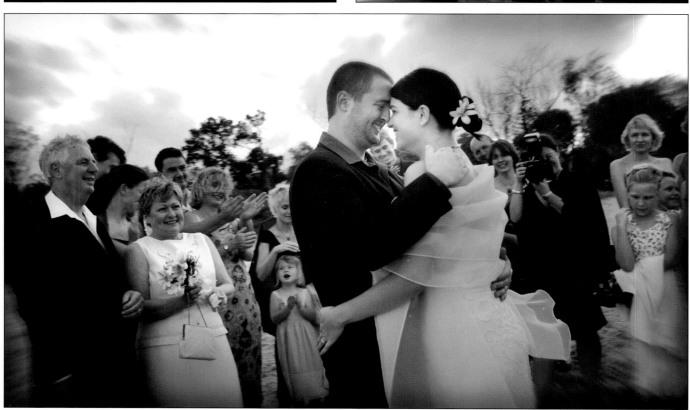

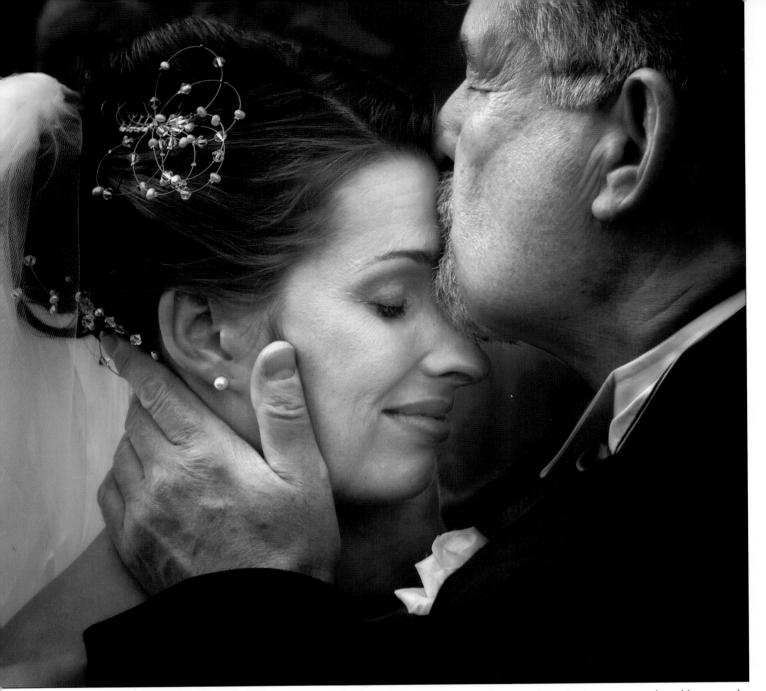

Captured during the rush of guests congratulating the bride and groom after the ceremony, this quiet moment was shared between the bride and her father. The image is significant for the family as it symbolizes the father saying goodbye to his daughter; the bride was to leave for America the following day to start her life with her new husband. To show only the two of them, I cropped the image; to emphasize the touch, I lightened that area of his hand and their faces. By highlighting these elements, your attention is drawn to the emotion of the moment.

The modern bride and groom know exactly what they want when they walk into your studio, even if they know very little about photography. The words *natural, simple, emotional, stylish, black & white,* and *documentary* are their catch phrases, and they have seen many examples of this style of work in their magazines.

Today, very few couples enter studios asking for posed portraiture and little else. Traditional portraiture still has its place in the wedding-day story, but its role is less prominent than in years past.

Photographic printing techniques and equipment have also changed markedly. In fact, couples being married today can expect their archival-quality images to be in perfect condition for their great grandchildren to enjoy. This is a tremendous innovation that will help link generations for centuries to come.

THE IRISHMAN

This image recalls a day that I will always cherish, a day that changed the way I viewed myself as a photographer.

In 1998, I embarked on my first photography journey, a trip that was four years in the planning and would take me through Europe for six months. The trip was designed to explore my heritage, as well as hone my skills as a photographer and develop the craft that had become my love and passion. It was a trip that, upon my return, would provide me with my faith as a photographer. Constantly on my mind during the trip was the question of whether I had what it takes to be a professional photographer.

Six weeks into the trip, my wife and I were exploring the bottom east tip of Ireland, near Ballinskellings (just off the ring of Kerry). We drove for miles up a dirt road and came across an artist village on the point of this peninsula. It was very remote and deserted—a beautiful, peaceful place. We spent quite a bit of time there and finally drew ourselves away. Half a mile down the road we passed an isolated, little farmhouse—there was nothing else around for miles. A man jumped out and waved us down. We pulled over and he started talking. He had such a strong Gaelic accent that we could barely understand him, but he was the most amazing-looking man.

Finally it became apparent that he was trying to give us his dog to look after. He told us that he could no longer afford to look after it and was desperately looking for a new owner. It was such a sad story.

Being travelers we could not agree to take his dog and, after a long conversation, we finally left with heavy hearts and headed down the road. Not more than a hundred feet farther along, it dawned on me that I should have asked to photograph him. Being so touched by the emotion of his story I had completely forgotten about my camera. Here he was, a man nearing the end of his life, helpless, and he simply wanted a better home for his trusted friend, his dog.

I stopped the car, grabbed my camera, and ran back to ask his permission to photograph him. He was reluctant at first, but as we kept talking I started to fire a few shots off and he began to relax, slowly forgetting about the camera, and just being himself. I noticed tears welling up in his eyes, and I took the shot I call *The Irishman*. Thinking I had taken things too far, I apologized, and he told me it wasn't the camera, but the fact that no one had ever taken the time to listen until my wife and I stopped to hear about his dog.

It was another six weeks before I was able to get the film processed and a contact sheet was made. It was at this point the

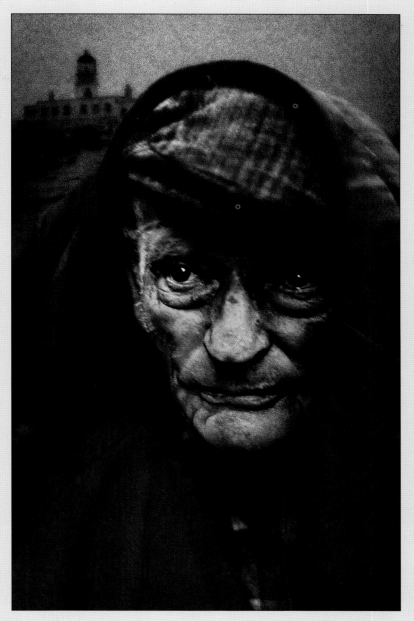

image just jumped out at me and I got a shiver down my spine. Never before had an image given me this feeling. It was then I realized I could really give my dream to be a professional photographer a shot.

This image inspired the rest of my trip and has influenced my career ever since.

Reflecting back on the day, I realize I had met a man who knew that his time was coming to an end. He wanted his only friend to be cared for when he was gone, and he could not go until he was sure his mate would be okay. At the time I was just a young man, at the beginning of my journey with my best friend, my wife. That day I knew my journey as a photographer was just starting. It is probably the most memorable and my favorite photograph.

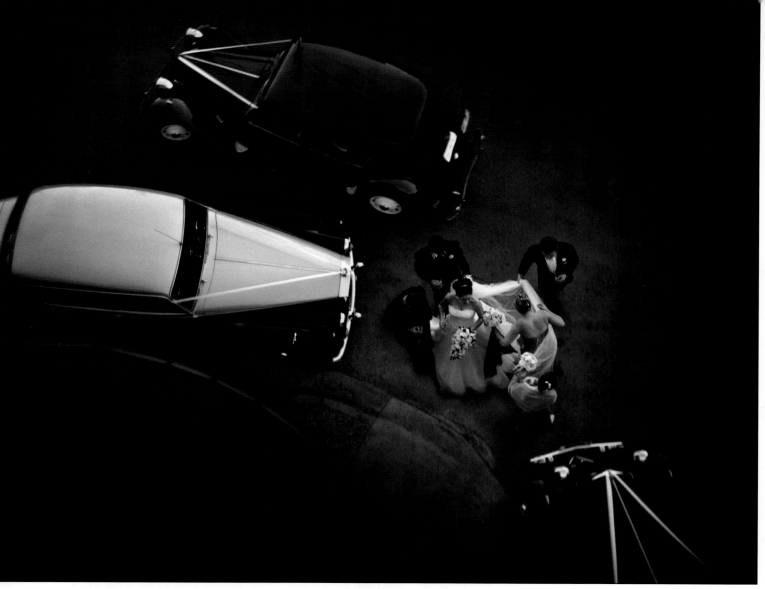

Waiting for the bridal party to arrive at the wedding reception, I was able to find a high spot to look down on the spectacle of the arrival in these beautiful vintage cars. Sometimes it is a matter of stopping for a moment to think from a different perspective, letting the moment just happen rather than drawing attention and staging such an event.

A DIFFERENT APPROACH

Wedding photography has traditionally been about formulating a standard shot list that would be utilized week after week, at every wedding, irrespective of the client's individual requirements. A shot list would usually include a long list of traditional poses and family groupings. It was quite rare to find any photojournalistic shots.

This book takes a different approach to traditional wedding photography. While some traditional and family portraits are still very relevant to contemporary wedding photography, I believe that they are only one element in the process of creating truly emotive wedding images. I have found over the years that my inspiration as a wedding photographer is every bit as important as

the technical aspects of my work. Photographers can be *artists,* and I approach my work from an artistic standpoint. This book will examine how your personal history affects your work and how you can use it to find and express meaning in your images. It will also show how, as an artist, you can draw inspiration from other fine-art mediums, and some unique ways you can capture images and provide your clients with a true document of their wedding day. The book draws traditional, classic, artistic, technical, business, and inspirational elements together in a unique approach to wedding photography that has shaped the success of my studio.

1. WHAT SHAPES YOUR PHOTOGRAPHY?

*I*t is a privilege and a passion to pick up a camera and make a life's work from the images produced. Great photography can only be created from a combination of passion and hard work, determination, and a commitment to excellence. We all started somewhere, and remembering our own unique journey as photographers can inspire us when we need it.

PIVOTAL MOMENTS IN YOUR LIFE

Photography was not my first career choice, although it's now certainly the best and last. When the workload of running a studio, raising a family, and making time for my wife and myself becomes overwhelming, I remind myself that I started at a completely different place, and it gives me the drive and perspective I need to continue striving for success.

I began my career working for a bank in Australia. Those who know me well, or at all, would say it is difficult to imagine me behind a desk, and it is just as difficult for me to remember myself working there. While working in the banking industry taught me a great deal that I could use down the road in my photography business, I was languishing in the 9-to-5 role and likely

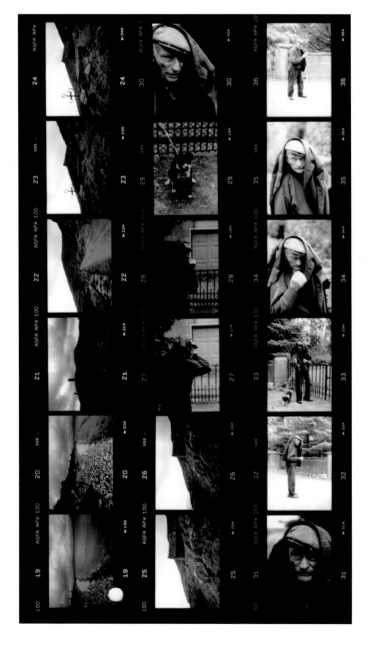

The story behind this image can be found on page 11. This contact sheet shows a number of the images I had taken of the old man and his dog, and the surrounding Irish scenery, which led to the final image, *The Irishman*. The image of the old man's hooded face stands out from the others, and viewing it for the first time was truly a defining moment for me as a photographer. For the first time, I could feel a shiver down my spine when viewing one of my images, and it made me think that maybe, just maybe, I had what it took to be a photographer.

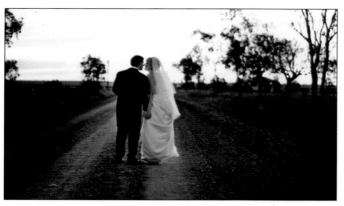

This is one of my earliest weddings, shot in rural Queensland. Hopefully I have come a long way as a photographer since capturing this image in 1996, but I would like to think that even back then I was trying to tell the story of the couple and their day.

The fact that my father was unable to attend my own wedding has had a significant impact on how I view others' weddings and what I want to capture for my clients. Through photography, I am also able to connect with him.

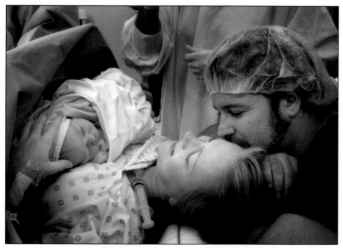

My camera is never far at important moments. The births of my sons only further resonated within me the importance of capturing important relationships in our lives and treasuring them while we can.

would not have earned any employee of the month awards, either. Every day was soul crushing, as anybody who has worked in a job that they lacked passion for could testify.

Inspired by the works and speeches of great photographers, and challenged by a need to connect with my father who had been a photographer before his death (just as his father before him), I began to learn the craft using my father's camera. Before long, I was photographing weddings on weekends for friends—and friends of friends.

A pivotal moment that led to my career as a photographer was a reprimand from a cranky photographer at a friend's wedding. He threatened to walk if I did not stop shooting, all because my gear looked slightly professional. When I later viewed the images he took, I felt that they did not depict the day as I experienced it and did not reflect the couple I knew as my friends and the love they shared. This incident inspired me to be a better photographer and to provide a better experience for the couple and their guests. It also transformed a hobby into a burgeoning career.

I did not waste time and began to learn as much as I could under the tutelage of Doug and Ruby Spowart, who threw me in at the deep end—the best environment in which to learn. They also introduced me to the Australian Institute of Professional Photographers, where I found a great supply of support, seminars, professional direction, and later, incredible friendships. I began regularly photographing the weddings of friends of friends on weekends, and my part-time studio was born (we all start somewhere!).

Still working in the finance industry during the week, I began to notice that some of my coworkers would leave the bank for twelve months at a time to travel the world. They would then return to their old jobs, but with a wealth of worldly experience. I, on the other hand, found myself doing the exact same things day after day. Witnessing this spurred my wife and I into action—we began to save for our own overseas adventure; the only difference was that I intended to never return to my old job. This trip, an opportunity to travel around Europe for six months and explore the world as a photographer, was a major turning point in my life. While there, I took the photo of the Irishman mentioned in the introduction and created a comprehensive

I noticed from the corner of my eye that the groom's father was almost as nervous as his son, and he seemed to be remembering and contemplating his own years of marriage as he twisted his wedding band over and over. It was a significant moment in which father and son were experiencing similar emotions. It is the ability to tell this kind of story for my clients that makes photography my passion.

body of work that would later inspire me to photograph weddings in an entirely new light. I knew then that I could make the transformation from a banker to a professional photographer.

It is important to take time to remember how you arrived at doing what you do. Outstanding professional photographers do not photograph because they kind of fell into it as a way to fill time; rather, it is usually the result of pivotal moments they have listened to and learned from. Stop and remember every now and again why you are a photographer.

Pivotal moments and people in our lives make us feel and think. They make us human. My father was the biggest inspiration in my life as a photographer. When I was sixteen, he was diagnosed with a brain tumor. He fought a brave battle for a year, but eventually succumbed to it. This experience helped me become the photographer I am today. At the time it made me grow up very quickly. It also showed me a grim reality of life and made me angry and resentful for such a great loss. Over time, I began to see how his passing impacted my work. If you look through my images, you will see over and over again how important family and friendships are to me. Though I am capturing images for my clients, I give a little of myself in every image. I have my father and the experience of losing him at a young age to thank for showing me the fragile gifts we are given by nature

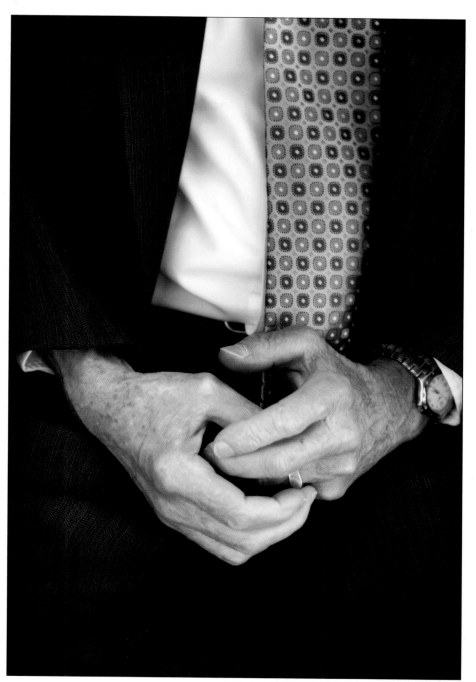

and why we should document and celebrate them at every opportunity.

The births of my son Jackson and, more recently, my twin boys, Rohan and Evan, have compounded the privilege of being a photographer. Their birth has also given me a clearer perspective of the success of my father's life. Having a family has also helped me to better understand the emotions a parent feels at his or her child's wedding.

Our experiences make us see what is important to us, and what is important in life. As photographers, we want to share that with other people. My experiences have

helped me to see elements that are special, things that many people would miss if I did not capture them.

My dad was not able to experience my wedding day with me, and I want to show people what they would be missing if those special people weren't around. When I go to other people's weddings, and there are fathers experiencing the day with them, I capture images of emotional intimacy—beautiful moments they will cherish forever. The experience is something that I missed out on, but it's an element I can help others cherish at their weddings.

It is amazing that it is our job to capture these moments for someone else. The images you shoot will be in a family for hundreds of years, handed down from generation to generation. Your legacy will live on, maybe just in the lives of those families, but perhaps on a much grander scale as well. Know that every photo you take is important.

THE INFLUENCE OF OTHER ARTISTS

Many photographers do not see themselves as artists. Yet, just like other artists, we photographers use what we think and feel to communicate a message. More photographers need to acknowledge that art is the heart of their profession. We have looked at what makes us feel and how it affects the images we create. As artists, it is imperative that we learn how to communicate these emotions in our work.

Learning from the Masters. To become a great photographer, you must constantly seek new inspirations and techniques to bring to your work. There is no better place to look for inspiration than in the work of the masters. By internalizing the principles of art, you can subconsciously call on them at any time, allowing you more time to capture the moment. Having this time means you can focus your energy on what is happening around you rather than worrying about technique.

Think about the most beautiful or thought-provoking images you have

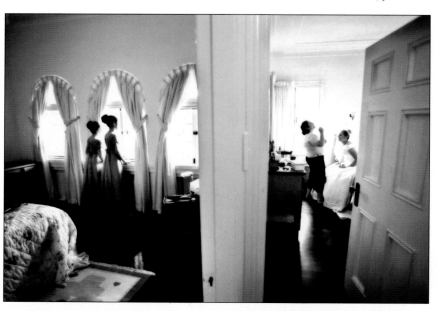

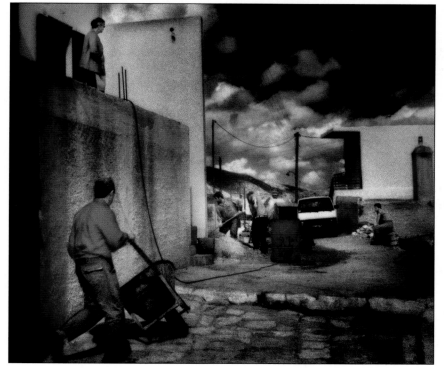

TOP—This is a scene that could easily have been depicted by the master artist Pieter de Hooch. By positioning myself between two rooms, I was able to tell the story of two bridesmaids waiting while the bride prepared for her big day. The elements of the composition combine to draw the viewer's attention to the center of focus, the bride. BOTTOM—The works of Jeffrey Smart have greatly inspired how I use color in my photographic images to create interest. In this image of the workers I have used this inspiration to handcolor a black & white image.

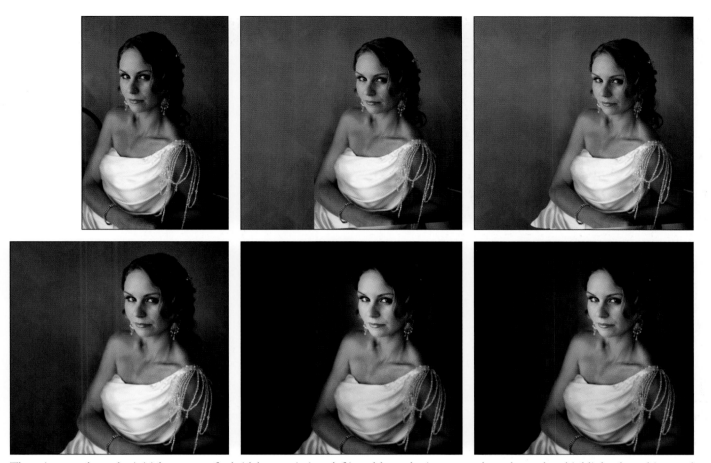

These images show the initial capture of a bridal portrait (top left) and how the image can be enhanced to highlight the subject and draw out the emotion (final image, bottom right). Even with all that work though, the decisive moment—when the right emotion crossed over the bride's face—is fundamental to the success of the image.

ever seen. It is the content that stands out, and this is what we need to concentrate on as photographers: content that expresses and evokes feeling and emotion. For instance, Jeffrey Smart is my favorite modern artist and is one of Australia's most celebrated painters. His work is distinguished by compositional rectitude and a range of sometimes unsettling, sometimes harmonious, but always intriguing and mysteriously hopeful emotional echoes. Smart's work revealed to me the way that painters use color to increase impact. It made me see how a photographer could use a blank canvas as well and change values to further enhance their images just as a painter does.

I suggest you go to art galleries and exhibitions, buy books on the great painters and sculptors, and analyze their work. Find the center of interest and determine how they have drawn your attention to it. Study how they use composition, and strive to understand their mind-set at the time they produced the work. What was going on in their world when they created the piece?

What is the history of the artist? How did their experience impact their art?

Evaluate the piece in relation to what the artist was trying to show and what is conveyed to you. Take note of any unusual techniques used, as well as the composition, color, contrast, presentation, light, and subject. Analyze why an image does or does not affect you, what you like or do not like about it. Having this understanding of what makes a great piece of artwork can dramatically increase your success in creating images. By applying what we learn, we become thinking artists who can convey a message. We have much to learn from artists of all genres, so remember to learn from the masters.

Using a camera to create an image is a relatively new phenomenon. Some art purists believe that, because of the perceived simplicity of capturing an image via a camera and because photography as an art from is in its infancy, photography is not as prestigious or as important as the work of an artist who places pigment to canvas. Thankfully, perceptions are slowly changing.

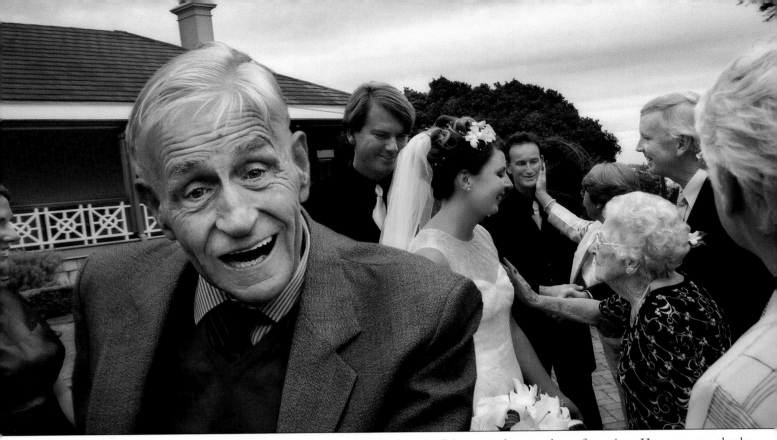

Images like this show how my work incorporates inspiration from some of the great photographers of our time. Here, you can clearly see the importance of the decisive moment, an idea instilled in me by Henri Cartier-Bresson. You can also see the influence of "human photographers" like Salgado, who take the time to get to know the subject in order to truly reflect the person they are photographing. This image did not merely happen by chance—it was the relationship and the rapport that was created with the couple and the guest that enabled me to photograph it. From there, clicking the shutter at the decisive moment in time enabled me to encapsulate the story.

It is interesting to note that some of the great *paintings* of our time originated as photographs. Using mirrors and/or a pin hole, artists projected an image onto canvas, then sketched it before using paint to reproduce what they saw with their own eyes. Vermeer, for one, used the camera obscura in his execution of *The Girl with a Red Hat*.

Whether primitive or modern, the camera is merely a tool. Painters, past and present, have used the techniques and tools of the photographer, and modern photographers can use the wealth of techniques employed by artists over the centuries—like composition, light, emotion, posing, etc.—to create fine art in the form of a photograph. If we acknowledge the artistic elements we use in our profession, we will see that the similarities between photographers and "traditional" artists are endless.

Influential Photographers. In addition to the great painters, there are several photographers—in particular, Elliott Erwitt, Henri Cartier-Bresson, Sabastiao Salgado, and Willy Ronis—who have had a major impact on my approach and photographic style. Initially, I was primarily inspired by their work and used their images as a benchmark to stretch my skills. Over time, I also learned to recognize the personality of the artists and have found that their views on photography are in some ways similar to mine.

I was lucky enough to meet Elliott Erwitt when he was in Australia and spent some time at my studio. Erwitt has an amazing eye for seeing wonder, humor, and beauty in the world. He is a true master and provides a valuable insight into how to open your eyes and look around you.

Henri Cartier-Bresson took his first photograph in 1932 and went on to become an iconic image maker. He did not consider his work to be fine art but rather documentary and journalistic, and it is this style that resonates in my work. Cartier-Bresson's photographic philosophy was built on capturing "the decisive moment," a phrase he coined. Throughout my career, this idea has shaped much of my approach to photography, and in particular my wedding photography. Cartier-Bresson

was not known for his people skills, as he was primarily interested in the image, not the subject.

Salgado, in contrast, is considered a "human photographer" or an "in-depth photographer of people." He believes that to create a great image of people you need to spend time with them and understand what is happening to them from their perspective. According to Peter Adams in "Legends—Sabastiao Salgado" (*Better Photography Magazine,* 41; Spring 2005), Salgado argues that Cartier-Bresson's journalistic style of photography does not afford this luxury.

Both approaches are equally valid and have significantly influenced my work. I believe that wedding photography provides the unique opportunity to combine the best elements of both approaches. There is an opportunity to meet your subject, get to know them, and learn what is important to them. Yet on the actual wedding day, capturing the decisive moment makes all the difference between *good* wedding photography and a truly *great* shot.

Willy Ronis is another photographer I admire and am inspired by. He is a brilliant photojournalist whose images capture the simple pleasures of everyday life. He does not focus on suffering; instead, his images tend to be lighthearted, humor-filled, and full of compassion.

Our styles can be influenced by a multitude of different people and mediums. I never dismiss a particular approach. Rather, I consider how elements of it may be consistent with my views. This has allowed me to grow as a photographer and develop a unique style that has not only become my signature but in some circles has been considered a new style altogether.

YOUR CLIENTS' PERSPECTIVES

Every client is different, so you need to be flexible in terms of your photography style and how you conduct yourself with each client. This does not mean completely changing you or your style, it simply means acknowledging and adapting to people's differences. For instance, I know some of my clients will want 80 percent photojournalistic and 20 percent classically posed images (or vice versa). With some clients you can be very open; with others you need to be more reserved.

My passion for photography isn't limited to weddings, it also encompasses a variety of genres, including landscapes and streetscapes. These pursuits do not exist in isolation; each feeds into and inspires the others.

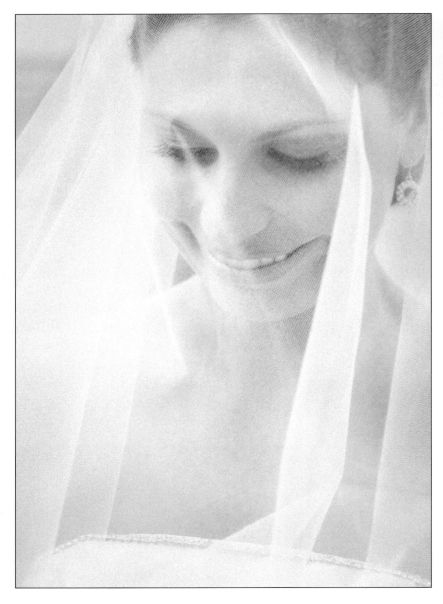

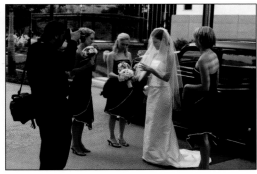

The relationship I create with my clients gives me permission to be very close to the subject yet remain virtually invisible—as you can see in the image above. I am not interacting, just observing; this takes the edge off of having a camera so close to the subject. To the left, you can see the image I took while working very near the bride, yet remaining unnoticed by her.

Understanding your clients has a major impact on your sales. If your images reflect the way your clients would like to see themselves, their friends, and their family, then additional sales come easily. When clients truly connect with the emotional content in the image, they are always more inclined to make a purchase. For this reason it is even more important to be flexible and attuned to the diversity of people.

Keep in mind, as well, that a wedding is not just about the bride and groom. Ask your clients questions so you will understand who is coming to the wedding. By listening intently to your client you can identify what is important to them and provide yourself with one of the most powerful tools for creating great wedding images: insight. For example, if a special guest flew across the world to see their friend get married, it will be important to capture a shot of them.

At the wedding, talking to the guests will help you get a sense of people's relationships with the bride and groom. Also, notice how the bride and groom interact with certain people. This will give you a guide to the importance of their various relationships and help you capture the images that will mean the most to the couple—photos that reconnect them with the day and with people who are important to them. A good lesson is that guests with flowers and corsages are *important*—now, isn't that easy to remember?

The following are a few examples of how understanding your clients can impact the images you create.

A Grandmother's Love. Before the wedding, this bride (see photos to the right) expressed to me how important her grandmother is in her life and how she played a major role in her upbringing. On the wedding day, I was talking with the grandmother and she made a passing comment that this room was where the bride played as a little girl. Based on this insight, I was able to incorporate further meaning in the portraits by choosing to shoot them in this special location. I further learned that it was the grandmother's sixtieth wedding anniversary and that the bride had chosen the same day to get married to honor their special relationship.

The two images I captured for them are a result of these insights and highlight the importance of actively listening. These portraits have become very important to the bride and her grandmother. They reflect their relationship, but also provide a special portrait of the grandmother on her wedding anniversary, signifying her own reflections on sixty years of marriage. The image also embodies how she has watched this little girl grow into a beautiful woman, and that on this day she will see her walk down the aisle—knowing that one day this little girl may watch her own granddaughter do the same.

The significance of these portraits is very evident, and you can imagine just how important they are for these two people and their family. Simply listening can give you the tools you need to create some of your finest work.

The importance of listening is very evident in the creation of these two portraits, which capture the relationship between these two women.

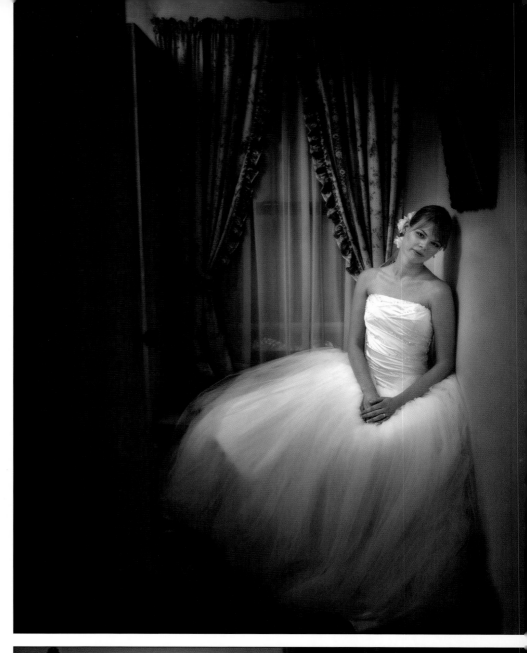

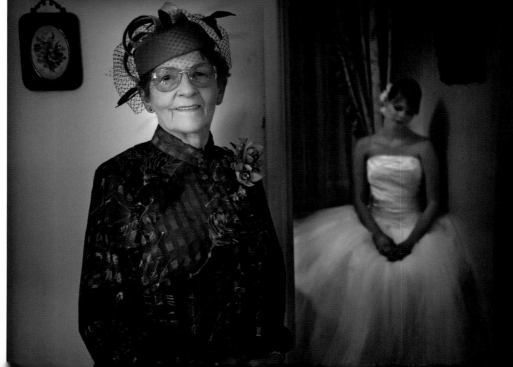

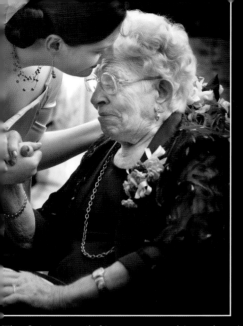
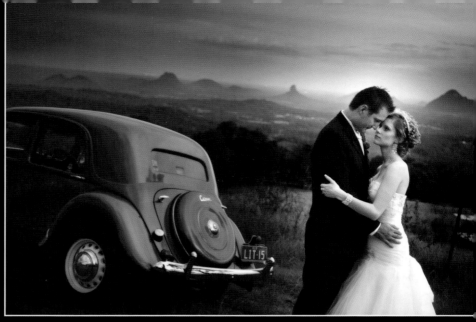

The first image (left) was captured in a photojournalistic style, and the second was captured as a classically posed image (right). Both show the emotion of the moment and achieve the same desired result, telling the story of the day.

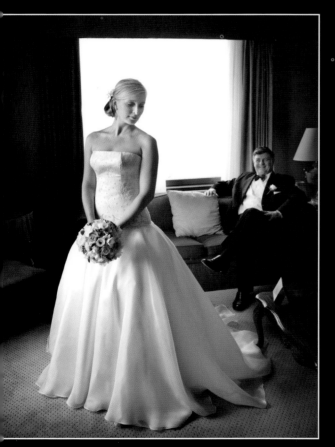

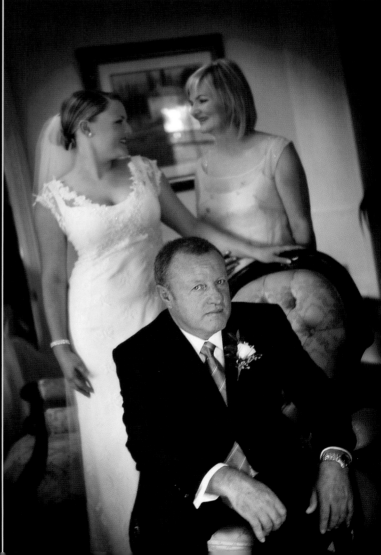

Highlighting key relationships for your client is very important. In these two images, the relationship of the daughter and the father is very evident. In the second image, the father noticed me setting up a portrait of the bride and decided to take a seat to take in the proceedings. He was unaware that he had just entered my framing. Rather than ask him to move I simply continued shooting, seeing this as an opportunity to highlight their relationship.

Colleen's Story. Two months before the wedding I received a call from the bride, who wanted to come into the studio and talk over a few things. As soon as she arrived I could sense something was not quite right. When we sat down, she told me that her father had passed away. One of the reasons she had hired me was to have some beautiful images of her and her father. The relationship I had built with her and her fiance made her feel comfortable enough to share this with me.

Come the wedding day, you could sense a tenderness of spirit and a special bond between the bride and her mother. Unwilling to have another in her father's place, she had decided to walk down the aisle on her own. A minute prior to her doing so, I noticed her mother walking down the aisle by herself and sitting down in the front pew. She was across the aisle from the groom's father. The image that I captured of his simple acknowledgement of support appears to the right. No words were exchanged, it was just a special moment between the groom's father and the bride's mother. Today, a new family will form and the bride's father's legacy will continue to live on with this new union.

This story and the resulting image demonstrate the importance of developing a strong relationship with your clients. Without that base I could not have been aware of the importance of what was happening. Knowing your client allows you to use your senses to observe what is happening around you and capture subtle yet powerful images. This image has also helped me to understand the loss of my own father, and that through my own children, his spirit and legacy live on.

SUMMARY

In this chapter, we have examined how studying the work of other artists can shape the images you capture.

We have also looked at the role of personal experience in the creation of images. As we've seen, the personal experiences of both the photographer and the client must be considered. As photographers, carefully considering our own history can propel our work from technically sound to all encompassing. It is what turns a photograph into art. By understanding and incorporating our clients' personalities in our work, we can create images that are more meaningful to them and, thereby, increase the number of images they wish to purchase for their album.

By endeavoring to employ all of these considerations, you can improve the quality and salability of your images—and the satisfaction you will derive from their creation.

One of the reasons this couple chose me as their photographer was because the bride loved how I highlighted the relationships between people. Sharing the same vision of the couple's wedding, we quickly built a strong relationship leading up to the wedding.

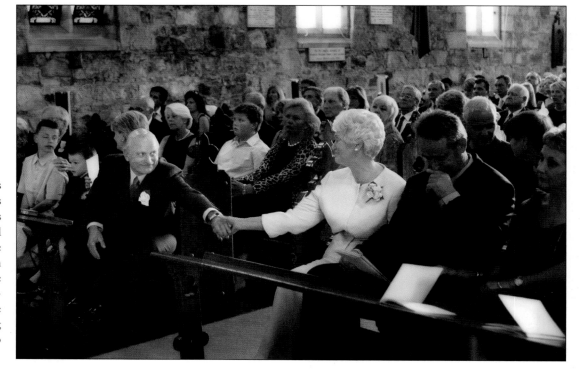

2. CREATING YOUR OWN STYLE

*I*n chapter 1, we explored the factors that shape how we photograph. In this chapter, we'll see that bringing those factors together forms the basis of your style. Creating your style is about linking your past, your ability, and what you value about life. The experiences that shape you as a person are unique, and your style is just as individual. Because of this, style cannot be bought or copied. Your style is you.

WHAT IS STYLE?

There are pressures for us to know our style; friends, prospective clients, and other photographers may even ask us to define it. Yet, when many photographers ask themselves what their style is, they are often stumped—or left wondering if they even have a style at all. It *can* be difficult to see your style for yourself, yet others can pick out your work a mile away.

In the early stages of your career, it's fine to simply let your style develop along the way and not to be consumed by defining it. Allow your style to evolve organically and concentrate on what you do best: making images. Once your style starts to become clearer to you, you can strive to develop and build upon your strengths.

For me, identifying my style has been about discovering what I love about photography. Once I understood this, I was able to further develop my style. It was only when I could identify my style, that I could brand it to my clients. Identifying "my style" meant I could target clients looking for the type of photography I do. This has become a very successful marketing tool and has increased the value of my product.

To better understand your own style it's important to be aware of and embrace the kind of photographer you are. Learn your strengths and build on them. This does not mean sticking exclusively to a particular style. Great images can be made by blending styles—building on your primary strength and gaining inspiration from other photographic techniques, for instance. The following

Using the power of observation and looking beyond what the bride and groom were doing resulted in this image.

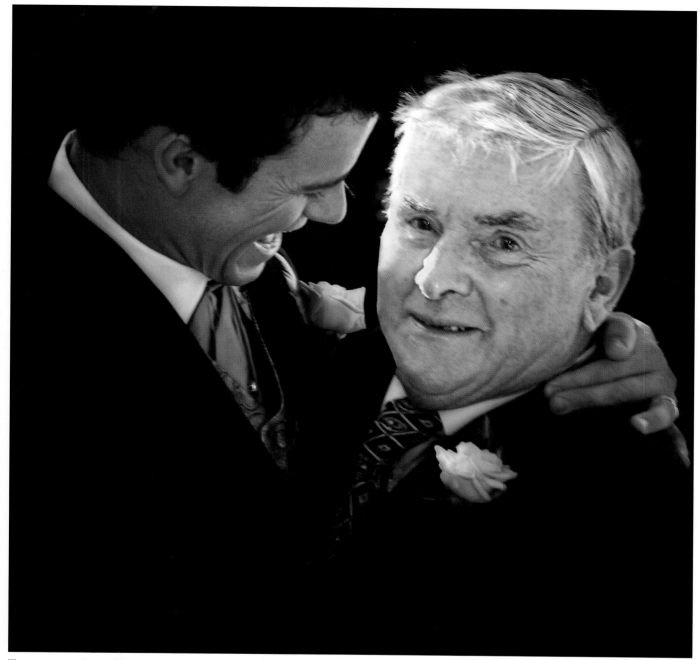

To capture an image like this is a great personal achievement, reflecting back to my wedding and the fact that I was unable to share this experience with my father. Giving the memory of this moment to a client is a wonderful reward. There are many similar moments throughout the day. Photographing them can boost the number of images you provide to your clients.

images illustrate that while my personal style is essentially photojournalistic, I often blend other photographic styles into my work to communicate more effectively.

APPLYING YOUR LIFE EXPERIENCE TO THE SHOOT

In every shoot there should be a little bit of you. Use your images to show your client things they would not have noticed for themselves. Connect and experience the moment yourself. Most of all, ask yourself what it is that you want to say.

GET PASSIONATE

A major element in exploring my photographic style has been reassessing the way I looked at all the images I capture. Early on in my career I saw a sharp distinction between my landscape images and my wedding images. One (landscapes) was clearly my passion, the other both

Incorporating different influences in you photography can add depth to your images. For example, combining my expertise in land-scape photography with my background in classical painting helped me to capture this moment.

my career and a financial necessity. It was only when I was able to apply the same passion I had for my land-scape photography to my wedding photography that I was able to capture the rewarding images I do today.

An important factor in this was changing my mind-set. I stopped thinking of wedding photography as a "necessity." There was a clear transformation when I just opened my eyes and really looked at all of the possibili-ties that could be captured at a wedding. Once I approached wedding photography from this perspective, it became my main photographic love. Suddenly every wedding was an opportunity to produce a body of work that pictured the complex lives of couples, their friends, and their families. The result is a body of work that has become my greatest to date.

THE STYLE EQUATION

This is only a starting point, but the following equation has been helpful to me in understanding my style.

Passion + Emotion + Decisive Moment = Style

How you define each element will depend on you. For me, passion was originally something I found only in my landscape images. Now, however, that passion is exhib-ited in all my wedding images. My passion comes from remembering that I am one of the lucky few in the world that make a living by capturing moments in time for people to share forever—and this is what drives my determination to work hard at my photography.

In my approach, I define emotion as capturing those intimate and special moments that are shared at wed-dings. Finally, capturing the "decisive moment," to me, means approaching weddings from a photojournalistic standpoint.

So find your passion, look for emotion in all that your shoot, and pick your decisive moment. When you do so, you'll have discovered your style.

DON'T BE LED ASTRAY

For a period, there was a perception that photographers had to conform to tradition. Thankfully, the tides have turned. However, photographers can now be led into conforming to "the next big thing." While it is impor-tant to find inspiration from other photographers and styles and current trends, it's also important to under-stand why you shoot the way you do. Ultimately, your clients are drawn to you in the first place because of *your distinct style*. Therefore, it's important to keep your core style in place while incorporating snippets of new styles.

3. THE PERFECT WEDDING IMAGE

hile insight into our history and beliefs and studying fine art can provide us with the background and inspiration we need to capture beautiful images, it takes more than this to produce fabulous wedding images. This chapter will look at some of the more practical aspects of wedding photography and how to make them second nature.

To capture an image for your client and then for that image to be enjoyed by them is a wonderful reward as a photographer. It's when you take that image to the next level that it truly becomes an achievement—and this is the goal of being a professional. In pursuit of excellence, an image not only needs to encompass all the technical aspects of a finely produced photograph, but also needs to exhibit great attention to detail, together with a great understanding of art principals.

This chapter will help guide your pursuit of the perfect wedding image.

WHAT MAKES A GOOD PHOTOGRAPH?

Any good "how to" photography book will describe the elements of a

This was shot when the groom arrived at the ceremony. It is important to capture the atmosphere before the bride arrives. There are people congratulating the groom, and there is always something going on that you can shoot.

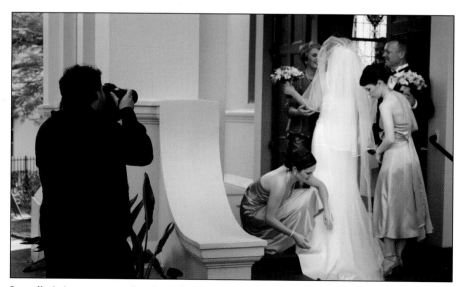

It really is important to be alert all the time. Here, I was capturing the bridesmaids fixing the dress when the mother of the bride popped out to give her daughter a kiss.

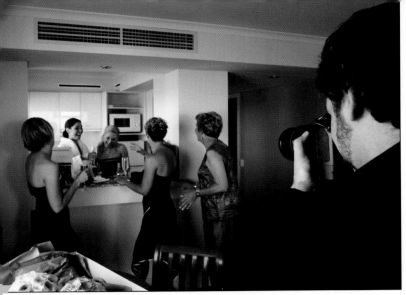

By observing from a distance, you allow people to be themselves. In this case, I noticed the family congregating in the kitchen to have a drink.

good photograph. To be a good photographer and produce great images, though, you must instill this knowledge in your subconscious so that using it becomes second nature. A list of the elements that good images possess follows. A more comprehensive treatment of some of the elements is presented later in this section.

1. *Impact.* The first impression is the lasting impression. What is the first thing you are drawn to? What commands your attention?
2. *Emotion.* Emotion is an important element in creating a great image. People love to be moved in some way by the images they look at, whether it be in a positive or negative way.
3. *Creativity.* Ensure that the image is original. Look into your imagination for inspiration. How creatively is the subject matter dealt with?
4. *Style.* Does the image present a different viewpoint? How does this work stand out from the crowd?
5. *Composition.* How are the key elements placed in the image?
6. *Light.* How delicately has light been used to present your subject?
7. *Color.* Be creative in your use of color. Include complementary colors in your images.
8. *Texture.* Texture can add depth and emotion to your images.
9. *Print Presentation.* An inappropriate presentation can ruin a great image, just as powerful presentation can make it.

Fine art and photography share all of the same fundamental elements. For me, a great photograph combines expression, personality, the identification and capture of a decisive moment, light, composition, and a background that says something about the subject. Creating a painting or a photograph is about allowing people to see aspects of a subject in a different light, opening their eyes to a different perspective. In my photography, I try to express how I see the world and allow the viewer to emotionally connect to the work. I strive to make them smile or feel a certain way about the subject. I do all of this to produce my own vision, be fulfilled in the art of photography, and feel a sense of accomplishment.

Lighting. Achieving the desired lighting in an image is critical to expressing your creative vision. The direction of the light on the scene, for instance, impacts the exposure for the image and determines its whole visual and emotional impact. The quality of lighting we use (whether it is hard or soft, cool or warm) also impacts the forms and colors in our images. We are able to use different types of light to portray the subject according to our artistic vision. For instance, by creating highlights in areas of interest, we call attention to that area. By creating shadows in other areas, we make them appear to recede.

I prefer to use only available light. I feel it maintains a delicate, natural look in my images, rather than the harsh, artificial feel produced by flash guns.

There are three main directions of light:

1. *Front Light.* Light that comes from in front of the subject is generally flat, meaning that there is an absence of shadows and modeling.
2. *Back Light.* Back lighting comes from behind the subject. Depending on your exposure, the mood of the image captured under these conditions can vary.
3. *Side Light.* Light coming from a right angle to the direction you are photographing is called side light. This produces shadows that define texture and form. The highlights and shadows often are the major parts of the composition.

Composition Basics. Composition is about how you choose to coordinate all the parts of a picture into a whole. It is a conscious decision and should not be left

to chance. Composition is, by nature, subjective. Everyone has his or her own unique vision.

Critical to successful composition is the ability to choose a center of interest—the one subject that is more important than all the others. Ask yourself what it is about a scene that draws your interest, and determine whether surrounding elements support or detract from the subject's magnetism. This process will help you decide what to include and, more importantly, what *not* to include.

Once you've selected a subject, the following tips will help you guide the viewer's eye through the frame in a progressive, structured manner. As a rule, we look from the left to the right through a picture, and it is important to keep this in mind when designing a photograph.

Simplicity
1. Keep backgrounds uncomplicated.
2. Separate the center of interest from less important image elements.

Placing a subject according to the rule of thirds (right) can create a powerful composition (below).

3. In general, position the center of interest away from the center of the frame.

The Rule of Thirds
1. Mentally superimpose a tic-tac-toe grid over your image and place the center of interest on a point where the lines intersect. These points are emphatic positions for the subject or the subject's most powerful element, like the eyes in a portrait.
2. Placing the subject at the left or right thirds line creates a dynamic image.

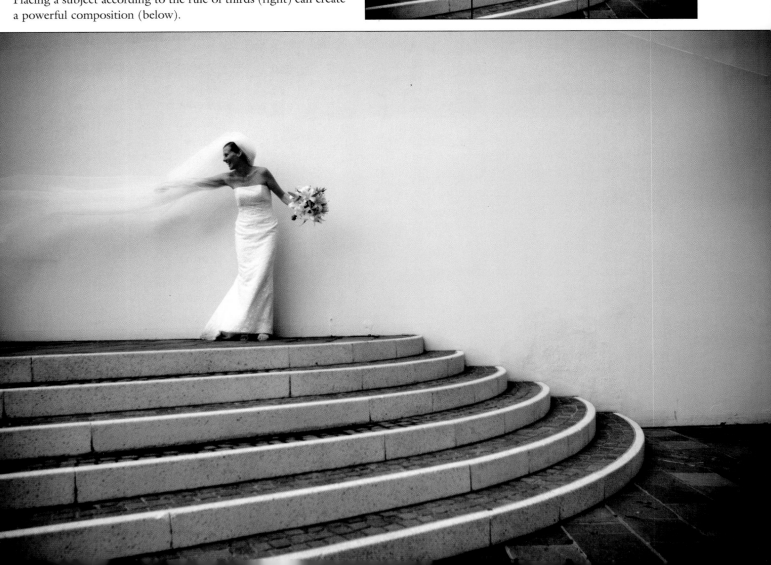

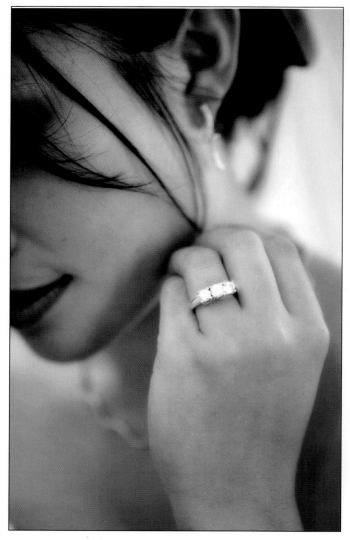

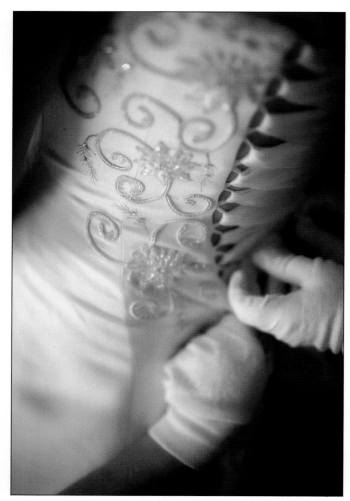

LEFT—The bride's hand and face create a gently sloped S curve. ABOVE—The hands and laced bodice create the same shape.

3. Positioning moving subjects on the left or right thirds line gives them room to move.

4. Place the horizon on a thirds line. In a scenic image, when the horizon is high, the viewer will spend more time looking at the landscape. Conversely, when the horizon is low, the viewer will focus on the sky.

5. When composing an image, place framing elements on the thirds lines.

The Use of Lines

1. Use diagonal lines as leading lines to guide the viewer's gaze from one side of the image to another. These lines should have a start, middle, and end. The lines should first direct the viewer to the point of interest, then through the image to points of lesser interest.

2. Diagonal lines are dynamic.

3. Look for S curves, an arrangement in which a major line, mass, or space between masses forms a gentle compound curve. Curved lines are pleasing to the eye.

4. Use geometric shapes like triangles, rectangles, and circles, bringing unity to the elements of your subject.

5. Vertical lines give the effect of dignity, slenderness, stability, power, and size.

6. Horizontal lines create a feeling of calm and peace.

7. Oblique and diagonal lines suggest energy and activity.

8. Triangular lines direct attention to the center of interest.

Balance

1. Balanced objects create order and a feeling of depth.

The diagonal lines created by the shadows of the bride and groom (top) and the railing (bottom) lead your eye right to the subjects of the photographs.

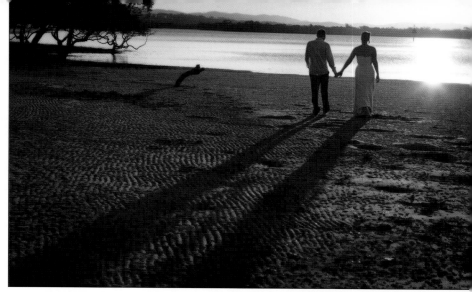

2. Arrange shapes, areas of light and dark, etc., in a pleasing way.
3. Avoid symmetrical balance—this gives the impression that two separate pictures are formed.
4. A small black subject needs a larger gray area or object (or even a larger white object) to balance out successfully. When the main subject is white, balance is critical owing to the fact that the eye is naturally attracted to bright or light colors.
5. Visual weight and balance is the difference between a good image and an excellent image.

Framing
1. Use foreground elements to frame background elements.

Mergers
1. Avoid including any background elements that merge with your center of interest.
2. Beware of border mergers where the subject is cropped too tightly.

Remember the guidelines presented above and, where possible, employ one or more element in every image you create. Remember that these points are only guidelines; you can stretch, bend, and completely break the rules to create your own compositional ideals.

I learned a lot about composition through my landscape photography. It is so important to have a center of interest and to read the light, as without these elements you would not be able to create a great photograph. I also incorporated streetscapes and people into my landscapes. Doing this deepened my skill level and created an interest for me in how people interact with or exist within their environment. It drove me to keep looking for that decisive moment.

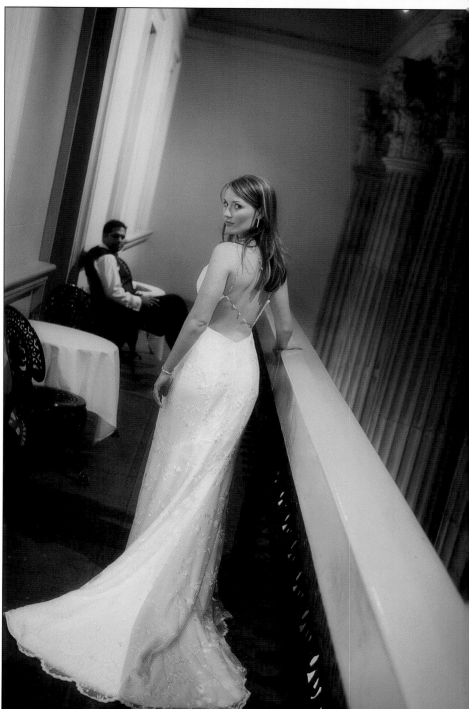

My skills expanded gradually and with practice became instinctive, until the elements of a great photograph were embedded in my subconscious. This means when photographing you can capture the moment in a split second. It gives you time to look and listen to the world around you, using all of your senses—sometimes anticipating what is going to happen, sometimes even willing it. Using these skills I photographed every opportunity I could, including major sporting events, even concerts. These different situations allowed me to

Before I arrived at this shoot, I knew that I would need to capture the small details in a very limited time and space. Sometimes you only need to make a minor adjustment to the way things are already arranged to make a great image.

hone my skills and freestyle, that is, use whatever skills and style the moment or client warranted.

Having an understanding of what makes a good photograph can dramatically increase the impact of your images. It is always a good idea to strive for a visually simple picture, which is usually more effective than a complex one. Simplicity, having only one visual center of interest rather than many, results in the strongest composition.

TIPS FOR SUCCESS

Make a Mental Shoot List. Nothing calms nerves and builds confidence in a photographer like feeling prepared before a shoot. Having a mental shoot list (a list that covers *what* to shoot but not *how* it will be shot) will mean that nothing gets missed and you will have more time to keep an eye out for fantastic photo opportunities. You should have clear idea of the type and style of shots you wish to capture and the overall shoot that you want to achieve, but be prepared to deviate from the list as needed. Generally, the more prepared you are, the more you can deviate from your list. It's also essential to incorporate the client's needs and wishes, as well as the occasional requests that will be made of you throughout the day.

A valuable technique for determining the subjects you may want to document it to write down every aspect of a wedding that you can think of—write down every photo opportunity and realize there are even more than that. Redo this for every wedding you attend. Before too long, these ideas will be cemented in your memory and will produce a visual diary, providing you with inspiration—and a built-in mental shoot list you can always fall back on.

See the Moment (and Improve It). Once you have determined specifically what you want to photograph, check for anything that might distract from that subject. Essentially, this means learning to identify what the subject is, then isolating it. This can be done by selecting the right moment to shoot (say, when the subject is framed by a door) or by modifying the subject's area of space, as I did in the shots on the facing page. In this case, there was wonderful natural light available for this bridal portrait, but the room was a little cluttered, so I had a bridesmaid hold the curtain behind the bride. The result is a beautiful and subtle effect.

the sequence of shots below (left), you can see me
 g to the bride and showing her the images I have
hot. I had noticed that she was lacking a little con-

fidence that morning and was probably a little nervous,
so I wanted to show her exactly how beautiful she
looked. I also showed one of her attendants, and the dif-

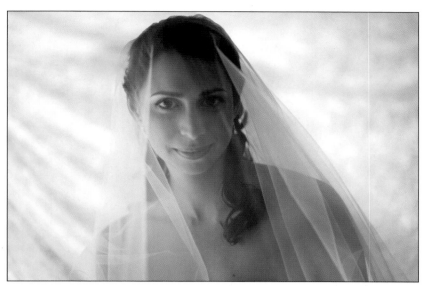

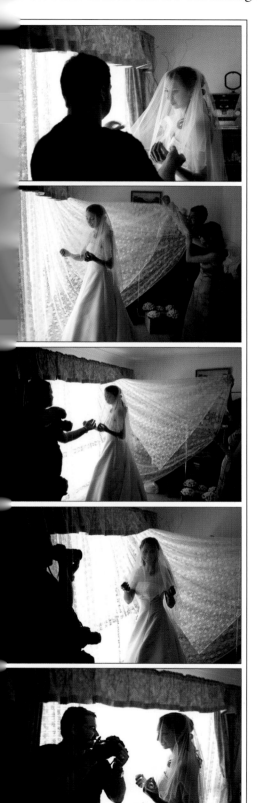

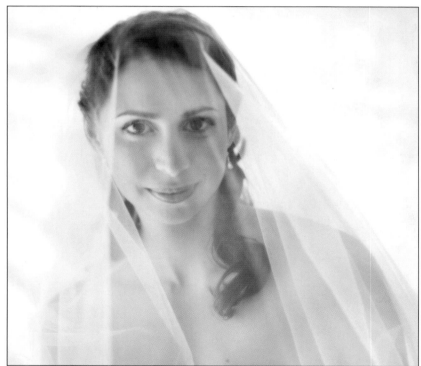

Not every bride will prepare for her wedding in front of the perfect photograph-
ic backdrop. Many times, it takes a little lateral thinking to make a beautiful back-
drop from the materials around you or to work around the background altogeth-
er. Having a bridesmaid hold a curtain behind the bride (left) gave us a great base
image to work with (top), allowing us to produce an essential portrait of the bride
(above).

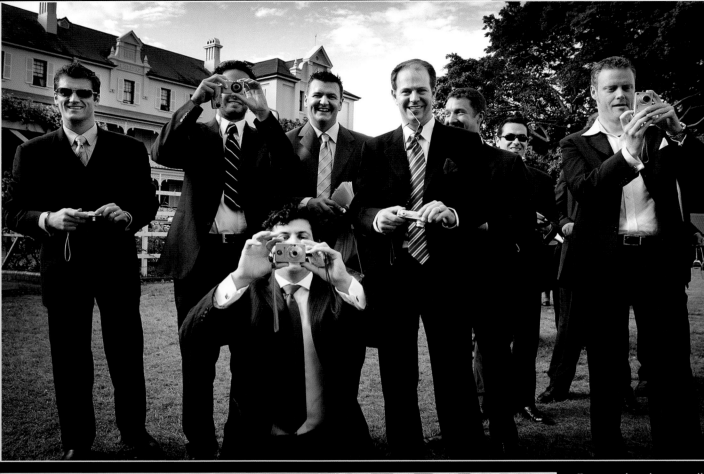

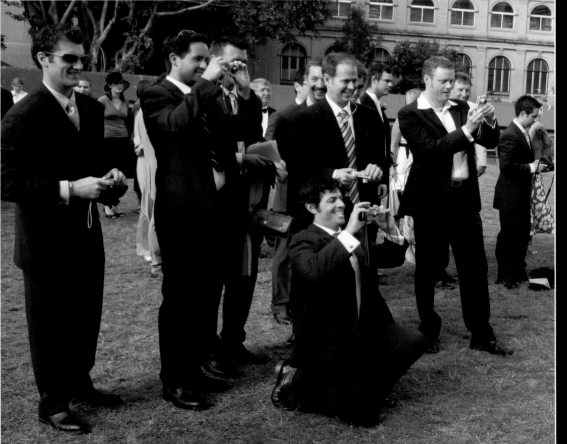

Capture the play as well
the play makers. Here I ha
captured some male gue
photographing their la
partners with the bride
noticed this from some d
tance and rushed to take t
image of the girls. Witho
a second thought, I sto
straight in front of the gu
took the image, and just
quickly moved to the ne
opportunity.

ference this made to her confidence levels was incredible. Remember the importance of helping to ease the nerves of your subjects.

Just as a side note, this series of images really shows how important lighting is in this shot. I had my assistant, Adam, photograph the setup shots (page 33, left), and he was working against the light in the same room. The result is obviously very different. Learning the art of seeing light and all its subtleties is an important tool for any photographer.

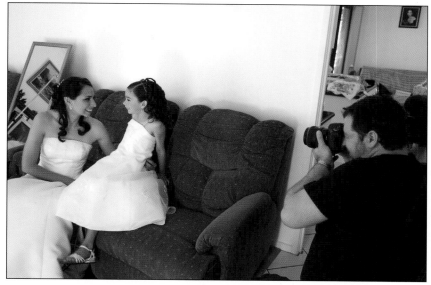

Again, the background presented some difficulties with the image that I wanted to capture—there were so many distractions around as I tried to capture the bride and her flower girl! By including only the subjects and softening the background by shooting at f/1.2, I eliminated many of the distractions. Changing the image to black & white subdued the remaining distractions and placed the focus directly on the subjects. Being a professional photographer means being able to work in any situation and still create a fantastic image.

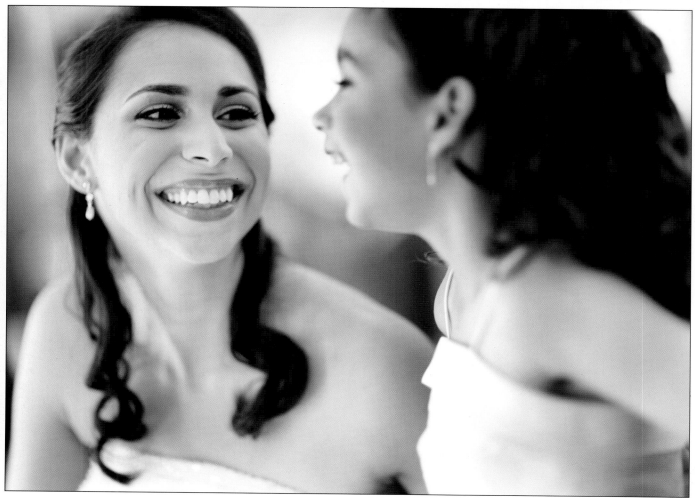

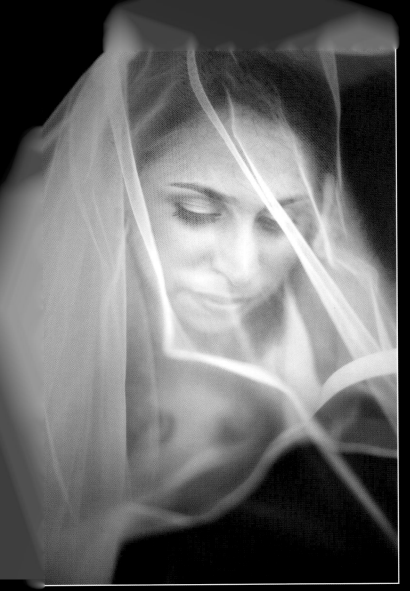

The bridal party was just being themselves and unwinding for a while (above). Amidst the laughter, I spotted this moment (left) when a bridesmaid pulled the veil over the couple. It just goes to show that there is never any downtime for a photographer at a wedding—you must be prepared at every moment.

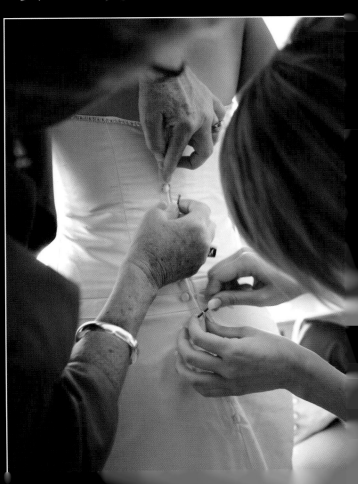

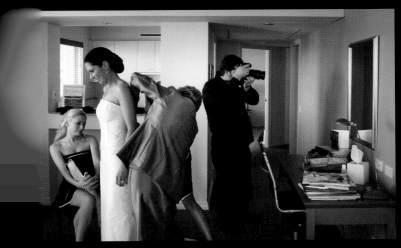

This image (right) shows how you can use your surroundings in capturing an image. In this case, using a mirror (above) allowed me to atch something I wouldn't have been able to shoot otherwise.

You can also isolate your subject by selecting the right moment in time. For example, the moment shown in the top pair of images on the facing page came and went in an instant. I was on location with the bridal party when they began to have a laugh with each other. Amongst all the charades, I noticed the bride and groom started to cuddle together. Then, a bridesmaid walked over and suddenly pulled the veil over them. I immediately saw the photo opportunity, so I just walked straight in and captured a series of images.

Hone Your People Skills. People photography presents image makers with a vast variety of subjects, expressions, situations, environments, and characters to document. This creates a challenge both technically and conceptually. Approaches to people photography vary immensely depending on the environment and the approach taken, but the following ideas will assist you when shooting photojournalistically.

1. Don't be obvious. Try to work unobtrusively.
2. Restrict the amount of equipment you carry.
3. Predetermine what and how you are going to shoot, then work with one lens. You can select a telephoto lens and work from a distance, or work in close with a wide angle lens and fire from the hip.
4. Work in environments where people usually have cameras. Also, try using smaller cameras so you don't stand out.
5. Work in crowded, noisy environments where you are less likely to be noticed.

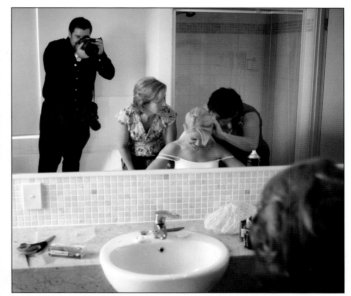

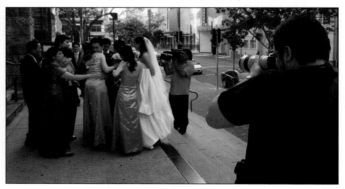

TOP LEFT—Look for vantage points that will give you either a different perspective or the ability to have a clear sight-line to your subjects. In this image I found a few blocks of sandstone that quickly gave me a different perspective. TOP RIGHT—Knowing your equipment is vital to shooting quickly, and reviewing how you carry your gear is equally important for ease of access. Not having to carry around a lot of gear enables me to be more mobile and to shoot unobtrusively. BOTTOM LEFT—Be enthusiastic, polite, and encouraging. When you are interacting with subjects, take the camera away from your face, make eye contact, and smile. BOTTOM RIGHT—Just prior to taking this image my card went full on the camera body with the short lens. Rather than miss an image, I switched bodies, moved back, and continued shooting with a telephoto.

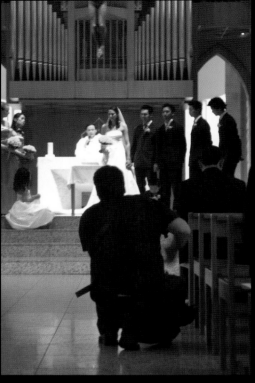

These are the sort of images (bottom) that I most love to capture—the immediate congratulations and the look on their faces as they come down the aisle. In preparation to capture these images (left and below) I will position myself a couple of rows from the front in the center of the aisle, ready for the bride and groom to be announced and congratulated by their parents as they make their way up the aisle.

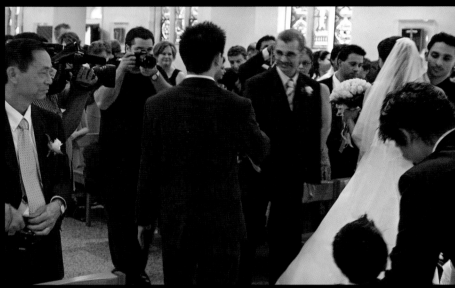

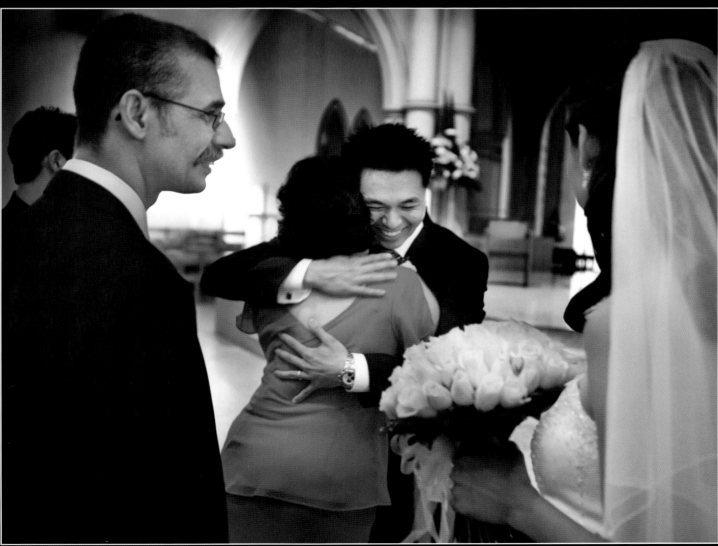

Often we only have seconds to capture what is happening, so I will go into a room and look at all the possibilities. Not only am I looking for light and composition, but for things to photograph. I saw these cufflinks on the vest and simply adjusted them slightly. Details are very important; it is imperative to capture them. You must also do this in the shortest possible time to ensure you are not missing a special moment for the bride or groom.

6. Preset your shutter speed, aperture, and focus so all you need to do is trip the shutter.

Your personality while you are working will either enhance or detract from the spirit of the day. You may be able afford to have an off day, but your clients can't—they will have to live with it for the rest of their lives! Therefore, it's important to respect your subjects and the environment you are photographing in, but also to put your subjects at ease. Be friendly, polite, and encouraging—and let your enthusiasm show. Keep an eye on your body language; people will reflect back to you what you communicate to them, so smile and be warm. This can make people feel calm and relaxed, even when being photographed. Move the camera away from your face when you are talking to the subjects. Do not become a

faceless photographer behind the lens; when you think about it, that doesn't show your subject much respect.

Get Organized. Organization is fundamental for a wedding photographer. You do not want to be rummaging for equipment when another great shot is unfolding. The time for organization has passed—and so will the moment if you do not act quickly!

Sometimes, anticipating a great shot that is about to unfold can ensure a great image. For example, toward the end of the ceremony, I usually retreat back one or two rows from the altar area to where the parents are sitting, as I know the couple will walk down the aisle and

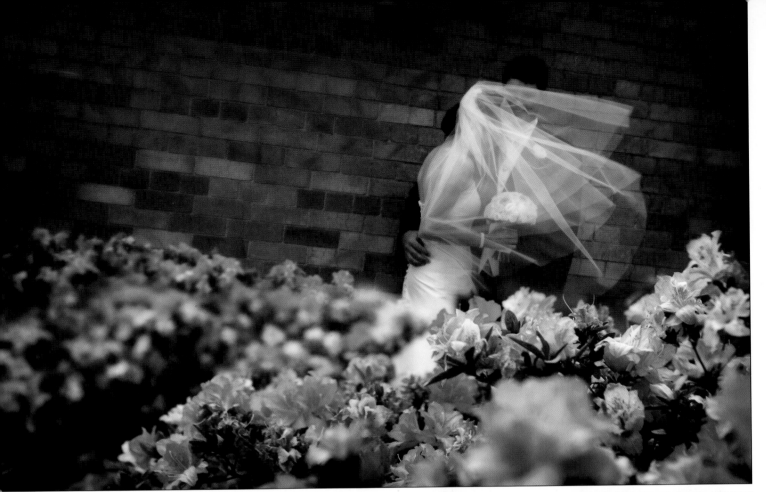

Sometimes a location you have shot before can produce a completely different image when photographed from a different perspective. Consider, for example, this image, which I took over flowers that are not in bloom at this church year round.

be congratulated when the ceremony ends. I kneel down to await the action, ready to strike. A few moments later, when the newlyweds are introduced, I am immediately up on my feet ready to capture. I place myself in the center of the aisle so I can track them coming back down the aisle. If I was off to the side, I could miss moments or get trapped, so I always tend to go for the middle. You need to evaluate and work within the boundaries of your environment. In an ideal world you would be able to get in closer, run around, and be right up in the action, but most churches and spaces are compact and you don't have that luxury. You must also be mindful of the guests and show respect for the environment in which you are working.

There is never downtime at a wedding, there is always something to photograph. In the last few years, I have attended friends' weddings and watched the photographers miss shot after shot because they were looking somewhere else, got distracted, or simply didn't see the

relevance and importance of that moment. This happens to all of us, but it is important to try to capture as many of these moments as possible before they are lost. Over time, you will raise the bar at every wedding you shoot. There will invariably be a missed moment, but you can take solace in knowing that, year after year, you are increasing the percentage of moments you capture at each wedding.

Know the Locations. Knowing the locations and lighting conditions you will be working in provides a key ingredient for previsualizing the event. This can be an

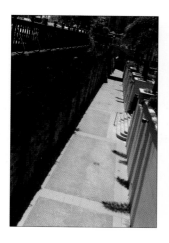

When possible, I do a location prep sheet (containing images of my scouted locations) for the weddings I photograph. Having a location prep sheet lets me conceptualize some images prior to the day.

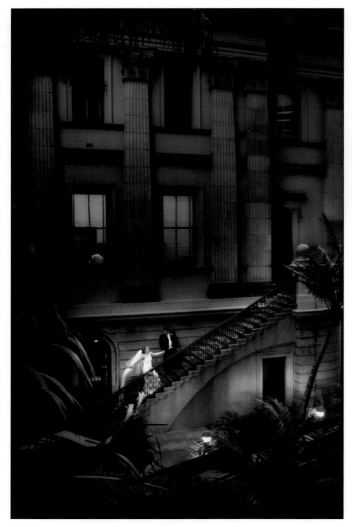

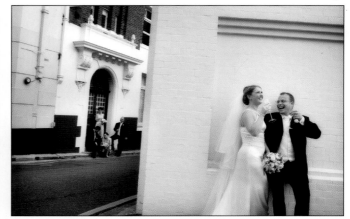

Great locations can be straight in front of you, it's just a matter of opening your eyes to the possibilities. The image above was create in an area where the cars pull up in the church grounds. Notice that both images were shot at locations that appear on my location prep sheet (previous page).

amazing tool, so have a notepad handy to sketch and write down your ideas as you are brainstorming them. The more experienced you are, the less previsualization you need to do; ideas will come more quickly while shooting.

While previsualization is extremely useful, don't become so intent on getting to your planned locations that you miss out on the opportunities all around you. Sometimes just turning the corner will provide you with a beautiful, close location that will have sentimental value to the bride and groom.

When possible, I do a location prep sheet (containing images of my scouted locations) for the weddings I photograph. Having a location prep sheet will give you the ability to conceptualize some images prior to the day. Printing out the prep sheet will enable you to reflect back to your initial plans and designs for the location shoot. I will do rough image designs using a red pen to show some of the possibilities the location will offer.

The completed images are a direct result of the detailed preplanning.

Although you may work at the same locations over and over again, it is important not to re-create the same old shots for every couple. Doing a dry run through the possible locations a couple of days before the wedding can open your eyes to new opportunities at even familiar locations.

It's also a good idea to have a number of alternate locations in mind in the event of inclement weather. This will allow you to spend more time capturing the moment rather than trying to look for ways to create it.

Photograph the Guests. Even though it is the couple's day, the wedding is not just about the bride and groom. Do not be afraid to get in and photograph the guests—that's why you are there.

To take these images, you need to overcome any fears you might have of getting right in front of people and photographing them without question. It's your right to be there to capture those images; the bride and groom have given you that privilege.

If approached by a subject, thank them for allowing you to photograph them. If questioned, explain to them what you are doing. You may also want to have an identification/business card handy or explain you have been asked by the bridal couple to photograph the people at the wedding—people who are very important to the bride and groom. Always smile, explain the beauty of the shot, and mention how each guest contributes to the story of the day.

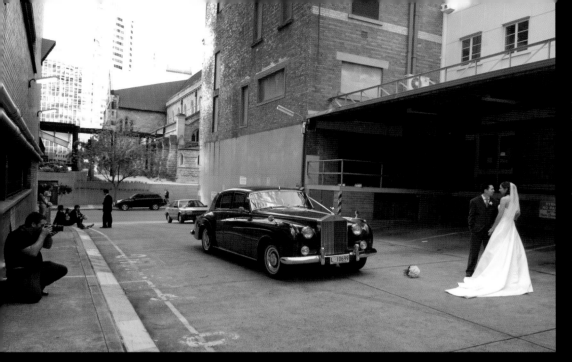

Scout the immediate areas around the church for additional locations. In this case I found an old lane with beautiful buildings that seemed to match with the car. I set up a portrait of the bride and groom, allowing them to interact naturally, then made sure the bridal party was at a distance so they could have a moment to themselves. In addition to photographing the couple, I turned around and captured a few shots of the bridal party.

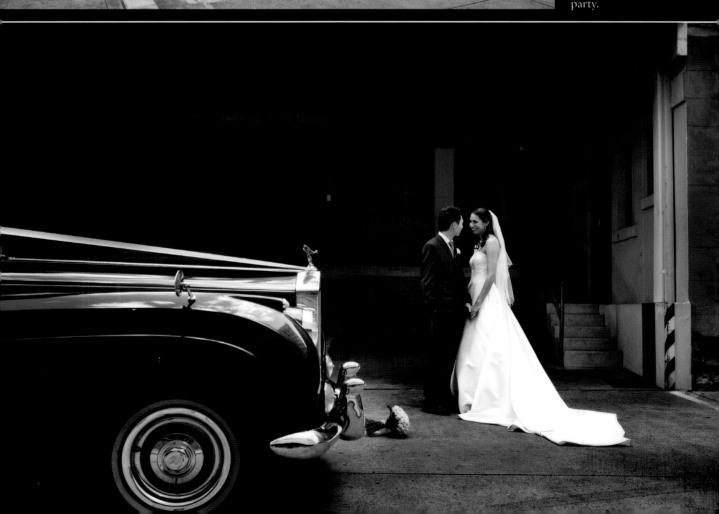

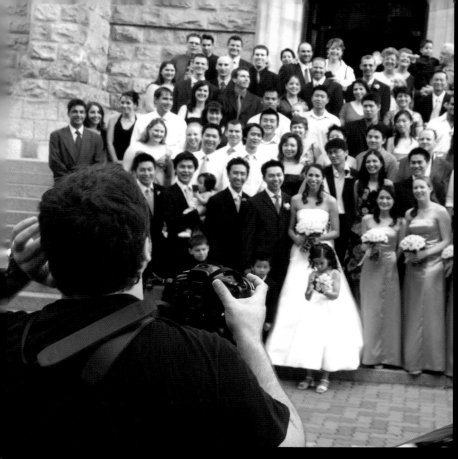

After the ceremony, you really have to come out of your shell to capture group shots. I smile and laugh with the guests to get them interacting and create an animated feel in the image. The image below is one of the photographs I caught from the setup show to the left. Just after the formal image, keep your eyes open for the funny moments that often happen as people relax.

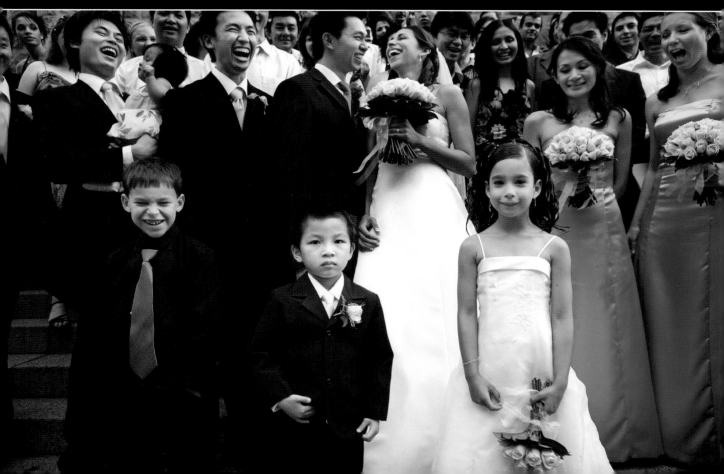

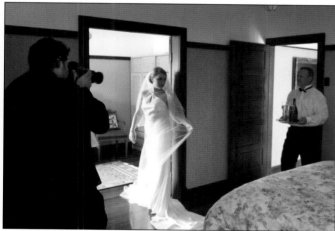

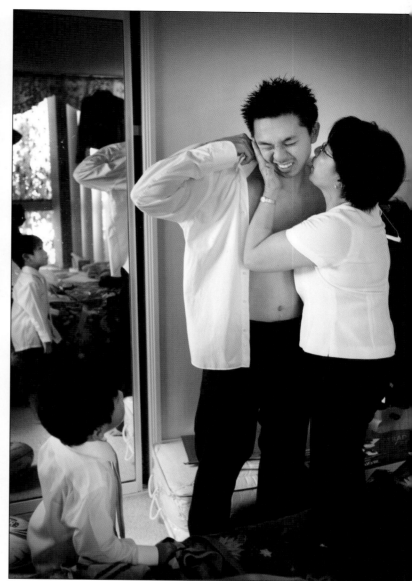

LEFT (TOP AND BOTTOM)—Some of the best moments in wedding photography are on the periphery. Keep an open mind for moments that might otherwise just slip by. RIGHT—Whether as a child or a parent, most of us can relate to this image. I could have waited for a posed, perfect image with staged expressions or the groom and his mother in their complete wedding-day attire, but I wanted to capture the truth of this loving relationship; the growth of a child to an adult and the reluctance of the parent to let go of the child who will always be their baby.

Stand back and watch the events unfold. Even when you think nothing is happening, keep your eyes open and be ready. What is happening around you? What are the parents, grandparents, children, etc., all doing? Creating these images is part of telling the complete story.

EACH WEDDING IS DIFFERENT

Some of the best photographs document spontaneous events, so get into the zone and look hard at what is really happening. As the photographer, you cannot *cre-*

ate the moment, but you have to be ready and able to capture it.

Each wedding will offer unique moments. As a wedding photographer, you may have attended hundreds or thousands of weddings, but it's important to look at each one with fresh eyes. Put yourself in the shoes of a guest and get in tune with the couple you are photographing. It is not a matter of just observing the day, but really *looking* at what is happening and *feeling* the emotions along with the couple and their friends and family.

The images above (left) are a good example of this. For some photographers, the father entering with drinks while they were trying to photograph the bride's portrait would be a distraction, even a hindrance. Unfortunately, the same photographer would be blind to the generous and symbolic gesture that this presents—a

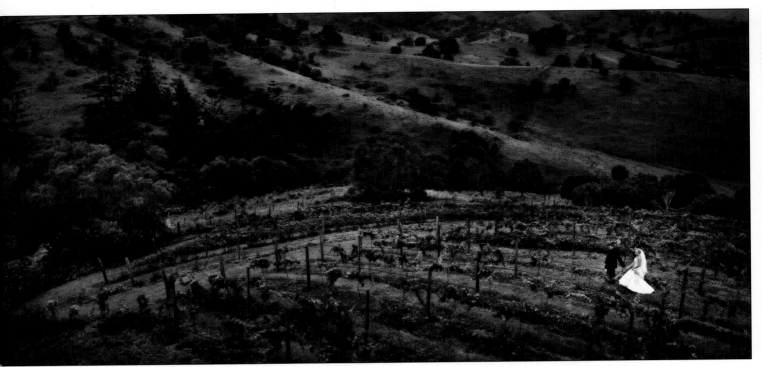

The completed image here scored a perfect 100 in WPPI print competition. Looking from the captured print (right) to the finished image (above) you can see how the elements are relatively unchanged other than what could be created in a wet darkroom. The image has been flipped and cropped for a stronger composition. It has also been heavily vignetted and darkened overall. To enhance the center of interest, the bride and groom have been lightened to ensure they are the brightest point in the print. You can see the importance of having a vision of what you want to produce at the time of capture, not just in postproduction.

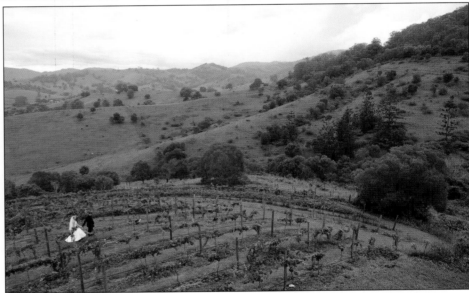

father wanting to cherish every moment with his daughter on her wedding day. These are important moments to capture.

SUMMARY

There are so many elements to becoming an outstanding wedding photographer, but if you simply focus on improving your skills at every wedding, you will quickly gain confidence and improve your images. This chapter examined how being prepared with a mental shoot list and arming yourself with the skills needed to recognize important moments as they occur are critical to success.

Consider how you would feel if it was your wedding and use your thoughts to guide your behavior. Make people feel at ease, be prepared to alter your shoot list to include close-by locations, and always be organized. Weddings are all different; they are one-time-only events that need to be captured right the first time. Remember, there is no second chance.

This is a series of images that shows how quickly I react when I see an opportunity to capture an image. Standing off to the side of the church during the ceremony, I noticed the bride and groom go over to their parents to thank them. I quickly captured the shots, making sure that I did not intrude on the moment, then quickly moved back. All the time I was keeping an eye on what was happening around me.

4. THE EVENT AS IT UNFOLDS

*W*e have looked at many aspects of how and why to shoot an image at a wedding. This chapter puts all of those elements together and follows the traditional order of the day, noting events you should keep your eye open for as well as how to turn a regular shot into something outstanding. Using techniques and inspirations from previous chapters, we'll look at ways to create images that tell the story of the day and consider some of the more technical aspects of the final image.

For this engagement portrait, I waited for the couple to interact naturally, then I made the composition work around them. By moving the camera and my position I was able to create the image without losing the relaxed moment. Using the wall and the lane provided a greater depth and enhanced the intimacy. I placed the faces in the top-right third to strengthen the composition.

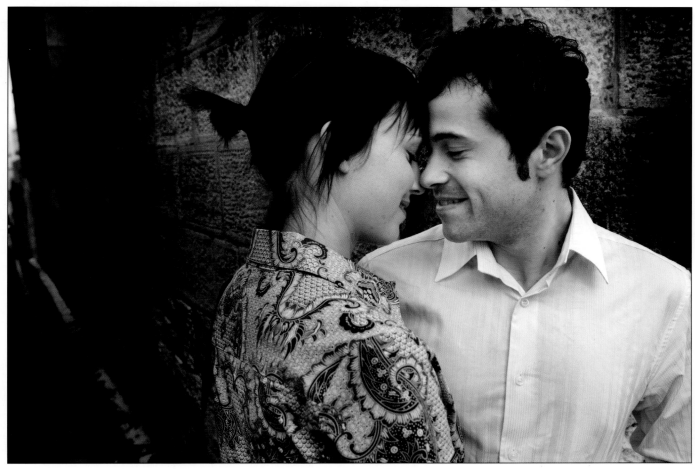

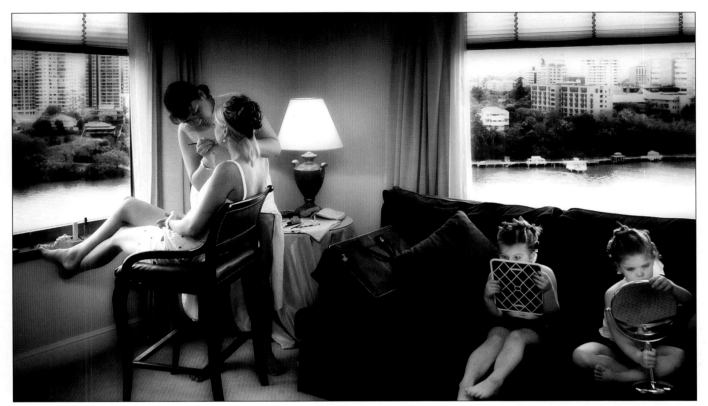

ABOVE—The bride had her makeup applied near the window and the flower girls pretended to be the bride. I framed the image to capture all the action and take advantage of the beautiful Brisbane River outside the window. Juxtaposition is the key to this image; there is a lot going on and it all fits perfectly. RIGHT—Here, the bride used the light from the lamp to apply a last-minute coat of lipstick, providing a fleeting opportunity for a portrait.

THE ENGAGEMENT SHOOT

The engagement shoot is your first opportunity to work with the bride and groom and begin to build a rapport with them. It's also a chance for them to see how you work. Often, couples have not spent any time, so take this opportunity to help them relax and feel comfortable with you. I find that walking them to the locations where we'll create their images can be helpful. (*Note:* I shoot most of my engagement portraits near my studio, so this is a five- to ten-minute walk.) On the way, we share light conversation about our lives, building a bond of friendship. By steering this conversation toward the clients, you can also use this time to learn about their families and gather information that will help you create more personalized images on their wedding day.

THE BRIDE

Preparations. There is so much going on in the bride's quarters on the morning of the wedding—it can be a

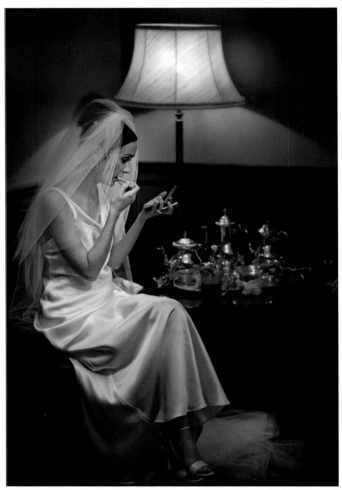

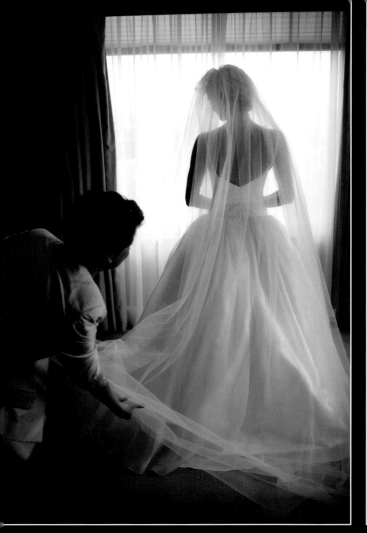

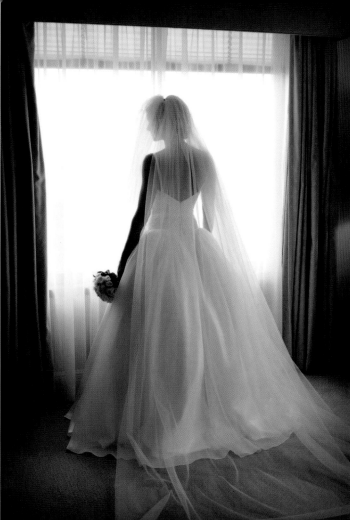

Many times the best images present themselves when you are not expecting them, so it is important to always be ready. In this picture I was positioning the bride in front of the window for a classic bridal portrait when the bride's mother stepped into the frame to adjust her daughter's wedding dress, wanting everything to be perfect. The mother entering the frame added another meaningful element to the image, turning it from a beautiful portrait to an intimate moment between the bride and her mother. This raises the value of the image to the client.

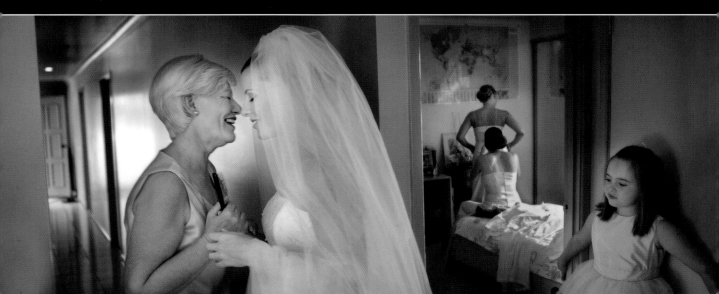

The bride was peeking into the room where the bridesmaids were getting ready when her mother came down the hallway and embraced he

nervous and excited room or calm and reflective, depending on the bride and her company. The relationship you have built with the bride will assist you in walking through these preparations unnoticed, allowing you to capture the mood and the ambience in the room.

Details. The bride will have spent a lot of time and money on the details of her day. Every part of her dress will have been well thought out and loved for a different reason. Her perfume, jewelry, shoes, headpiece, and flowers will have been hand-picked for the occasion, and she will want to have a lasting image of all of them. Identifying and capturing these small details in an interesting, artistic way is important.

Key Relationships. Often there are many people present as the bride prepares. Some of them will be there to provide services, others because they have a special relationship with her. Keep an eye out for small interactions between them that highlight this relationship so that you can document these moments outside of a tra-

ditional portrait format. It is these images that will hold the most value to the client. (*Note:* Don't dismiss the possiblility that the person doing the hair and makeup may be a close friend or family member.)

Bride's Family Portrait. The formal family portrait is very important, especially to the bride's parents. Family portraits also help tell the story within an album, so images that show emotion and action can sometimes speak louder than the perfect positioning and lighting. During the bride's preparation time it is important to achieve both a formal portrait of the family and to also capture a portrait that is more journalistic.

The Bridal Attendants. The bride has painstakingly selected her own attire, as well as the outfits and accessories worn by her attendants, and this will provide you with fantastic subjects for your images. The bridal attendants will be either old friends or close family members with a strong bond with the bride. It's important to capture natural-looking images of the bridesmaids as a

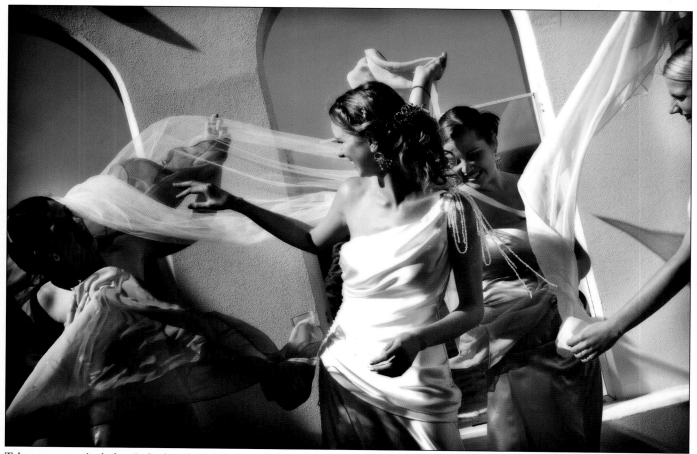

Taken on a particularly windy day, this photo was designed to make the most of the elements and ensure that the bridal party continued to have a good time despite the weather. Using the rapport built with the bridal party, this photo simply evolved when a gust of wind took hold of one of the girl's wraps. It quickly turned into a game; I just encouraged it and moved around the subjects, shooting what was happening.

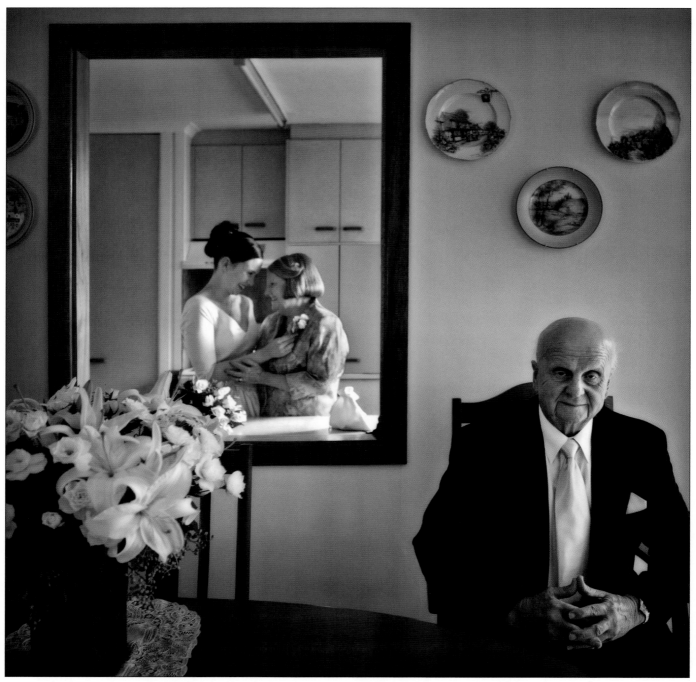

I noticed how proud and special this day was for the father of the bride. I saw how much the mother fussed over the daughter and what a bond they had and this led to a wonderful opportunity to pose this image. To capture a true portrait of this man, I knew that I had to include the two most important people in his life: his wife and his daughter. A full 95 percent of my images are captured using only available light, and this image is no exception. Here I was able to take advantage of two sets of windows, both lighting the subjects separately. Maximizing the use of the light around you is an important element to mastering every image you create.

whole group, individually, and in smaller groups. Then, take some time to find a beautiful backdrop and position them for a more formal image.

Keep in mind that this can still be a natural-looking photograph, even in a controlled environment. By both observing interactions and employing a more formal approach (but in an inviting way) you cannot help but capture something special.

A Proud Day. A prouder day is unlikely to materialize for parents than the day they give their daughter away to be married. Often it is a bittersweet day of loss and gain for parents—but it is also a day during which

In this photograph the elements of fine-art composition have been introduced by positioning the bride off to the side and using natural lighting to highlight the subject. The background elements are subtle; they complement the bride and tell the story of the day ahead. Including the bridesmaid walking away adds to the subtle complexity of the image and hints at the story unfolding around the bride; amidst the quietness of the moment, there still is a flurry of activity in preparation for the day.

they are bursting with pride. Look for opportunities to capture these emotions in the small amount of time they have together alone before the ceremony.

The Bridal Portrait. Every bride will want a beautiful portrait of herself on her wedding day. For most women, this is one day in their lives where they want to look absolutely perfect. When shooting the bride's portrait it is important to keep in mind her personality and the image she has worked to create. Your aim is to provide her with one of the most beautiful images she will ever see of herself, a lasting reminder of youth, beauty, and love.

THE GROOM

Shooting the groom's images requires some different skills that creating the bride's images. Men are generally more uncomfortable in front of the lens; even on a normal day, they may find it difficult to sit still—let alone a day filled with nervous energy! While the bride's images have a feminine touch, the groom's images must speak of masculinity and display the character of the subjects—as well as a sensitivity to the moment. Using your powers of observation, adjust your approach to gain acceptance and earn the respect of the men.

The Details. Just like the bride, the groom will have spent time and money putting together his look for the day.

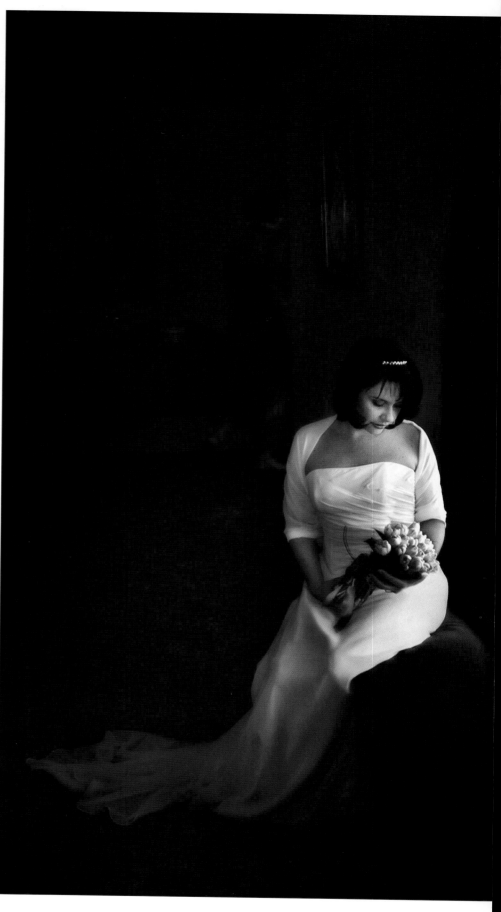

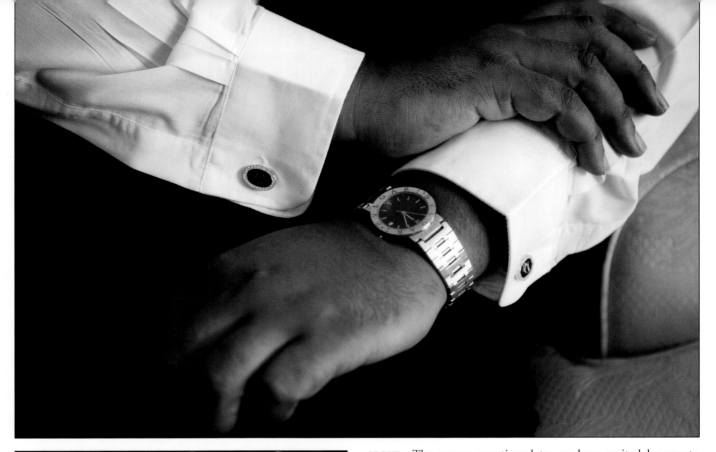

ABOVE—The groom mentioned to me how excited he was to receive these special Christian Dior cufflinks from his father, who had received them years ago from his own father on his wedding day. It is important to find out about any special details like this and capture them for the groom. LEFT—This is a classic portrait reflecting the traditional elements of the wedding. The columns in the background were used to reflect the nature of the subject—professional, strong, and forthright with a slightly formal feel. In photographing the groom, take time to consider the location and composition. I posed this image to bring out the strong and trustworthy character of the groom.

Weddings are often an opportunity for parents to pass down an heirloom or a special gift to be given from them or the bride. Be sure to know if there are any special items the groom has with him on the day to shoot.

Portrait of a Man. Considering the location and composition of the portrait is critical in creating a groom's portrait. Gaining his trust by cultivating a strong relationship prior to the wedding day is also imperative to capturing natural-looking images that he feels comfortable in. The engagement shoot will have prepared him for how you work and how he looks best through the lens.

Key Relationships. A wedding is a hectic affair by anyone's standards. Many times the bride and groom come to the end of the day and realize that they have

not been able to speak with everyone they meant to, or that they only got to spend a small amount of time with an important friend or relative. As a photographer, it is important to know who is special to the bride and groom and keep an eye out for moments of contact. Shooting as a photojournalist is the best way to capture the raw emotion of each moment, so remember to keep an eye on the action and what the key players are doing.

The Groom's Family Portrait. Many portraits of the groom's family fail to show emotion, often because the subjects feel uncomfortable when being posed. Using a photojournalistic technique and being aware of the moment, however, allows you to capture images where emotion is evident. Taking this approach will provide you with a cache of images that speak of the true relationships in the groom's life.

When posing is required, carry yourself in a relaxed casual manner rather than being overly formal and controlling. Your subjects will feel much more at ease and be more willing to participate.

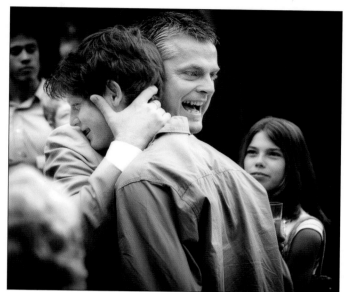

RIGHT—In this image, the groom leaves behind the crowd to share some time with his son from a previous marriage. The moment was so special, because the son could have easily been lost in the shuffle of the after-ceremony congratulations. Yet the groom sought him out and made the connection. BELOW—Posing this image would never have carried as much impact as being ready when a natural congratulatory hug took place. All of the self-consciousness and timed smiles are missing and the true feeling is present.

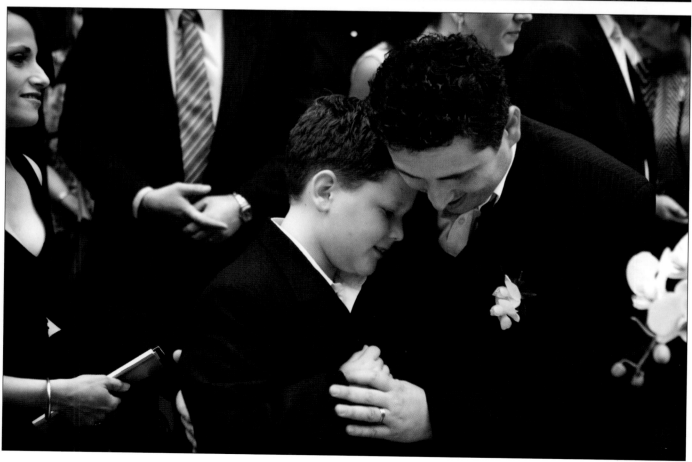

LEFT—This groom and his attendants all went to the Anglican Church Grammar School, also fondly known as Churchie. With the ceremony taking place at the Churchie Chapel, it provided a wonderful opportunity to shoot these boys turned into men walking up the stairs they had trodden thousands of times before. I noticed three boys coming down the stairs and could immediately see the irony in the image, with three boys entering their school years whilst three men were opening a new chapter in theirs. This is another example of how fundamental the relationship you build with the clients is. Without a strong rapport, a detail like this could easily be missed. RIGHT—Having an assistant or guest at the ready to alert you when the bride arrives will give you the opportunity to photograph more of the complete story. In this image, I used the background in the church to capture the day from the perspective of the anxious groom.

The Groomsmen. Very often, the groomsmen share a bond with the groom that stretches back to their school days or earlier. They will be enjoying their time together on the wedding day like no one else attending. Get to know the attendants during the shoot and allow things to happen naturally rather than posing every shot.

An Anxious Wait. When the time draws close to the bride's arrival, you can often feel the anticipation. The church is almost full and humming with the conversation of the guests, the officiant is doing last-minute preparations, and the groom is a nervous bundle of energy. If you are outside waiting for the bride to arrive, then all of this can be easily missed. So, if possible, have someone there who can alert you to the bridal car arriving so that you can shoot the action inside the church while you wait.

GUESTS ARRIVING

So much is happening as the guests arrive at the church. Friends and relatives who have not seen each other for years are catching up, the final touches are being attended to inside and outside of the church, and the moment when the guests begin to pour into their seats can be quite an exciting time if captured well. Look for the guests arriving, then capture them talking in the aisles, taking in the decorations, and reading the order of service. These are moments the bride will not get to see for herself, so your images will add to the story of the day.

Some of the most glorious images come from outside the church before the ceremony. Everyone is distracted and at the height of excitement and, therefore, blissfully unaware of your presence. Walk quickly and quietly around the scene and capture these moments before the bride begins her walk down the aisle.

Keep in mind that the bride actually misses all of this because she arrives at the ceremony venue last. The groom may also miss the excitement due to nerves. Therefore, it is especially important to walk around and shoot the action where possible so the couple can get a feel for the buzz that preceded the ceremony.

In this image, the very first of the guests are arriving. The bride, and often the groom, would normally miss the buzz of this moment, so it is important to capture it for them.

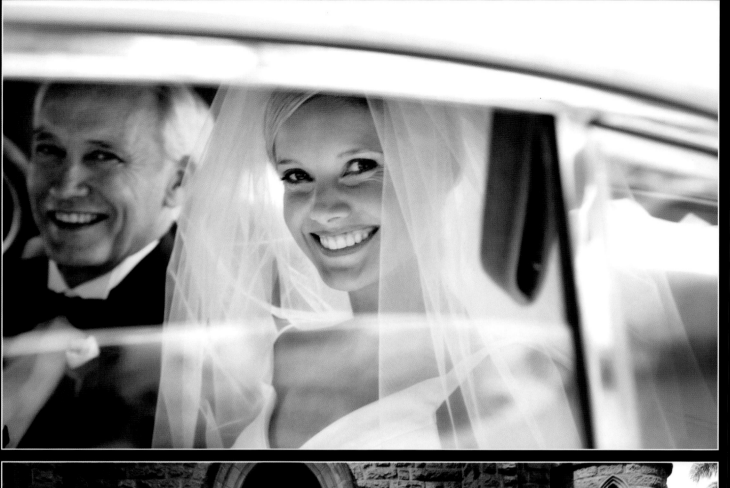

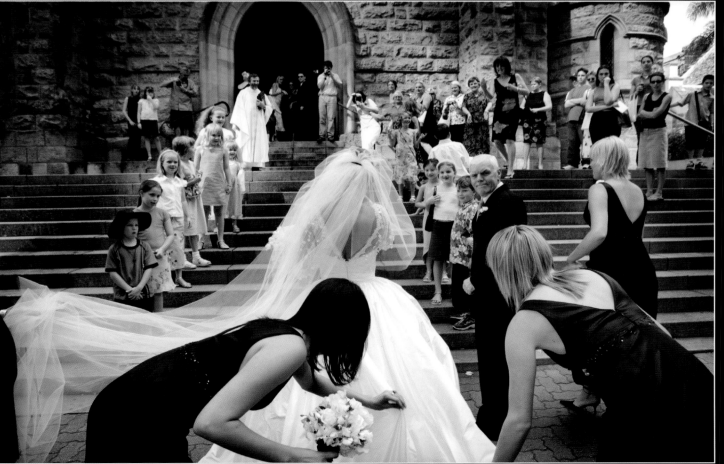

THE BRIDE ARRIVES

After we leave the bride's house, I will shoot photojournalistically until we do the family portraits after the ceremony. The one exception is the shot I will create when the bride arrives at the church. To prepare for this, I advise the bride to remain in her car when she arrives at the church. By letting her know exactly what to do, I can capture great moments of the groom and guests waiting inside without having to worry about missing the bride's arrival.

THE CEREMONY

The ceremony is what a year's worth of preparation has been about. Everything comes down to this moment for the bride and groom, and this is a one-time proposition for the photographer. A moment missed or not captured fully is a moment that is gone forever. Being prepared and calm during the ceremony is critical to the success of your wedding photography.

Father and Daughter. Having her father walk her down the aisle on her wedding day is the dream of many

FACING PAGE (TOP)—This image encapsulates the thoughts of a bride before going down the aisle. She is looking beyond the camera to the setting that she has seen over and over again in her mind. FACING PAGE (BOTTOM)—When taking these photographs, it is important to stay back from the action and move around the scene quickly and precisely to avoid bringing attention to yourself. In this image, the life of the bride is highlighted through framing the children on the stairs. The moment within the day is revealed by the actions of the bridesmaids in the foreground. RIGHT—In this kind of photo, you need to decide if you want to portray the scene as a silhouette or if you want to show the detail. In this image, I wanted to show the exchange between the bride and her father. To achieve this detail I increased the exposure by three stops to compensate for the outdoor light.

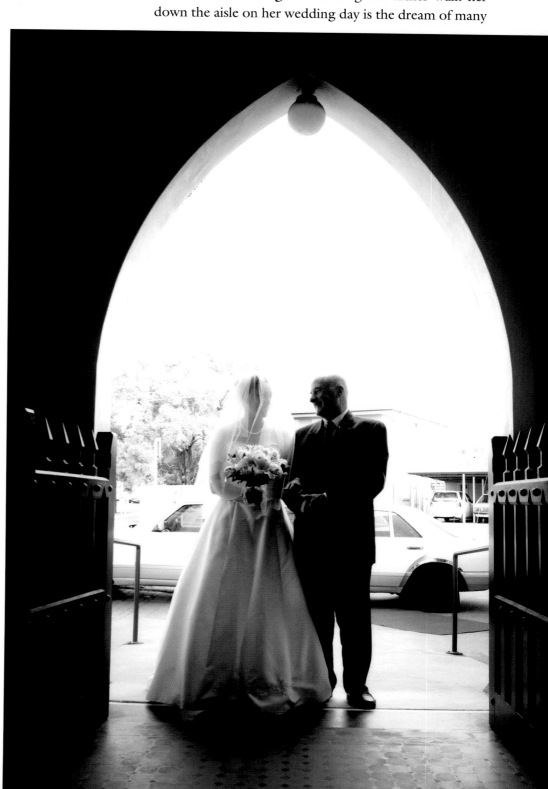

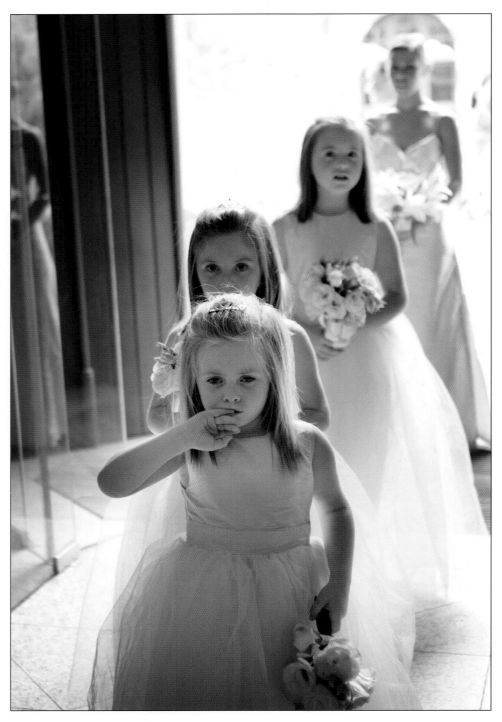

a little girl—and one of the proudest moments in a father's life. This walk will be emotional for both parties and the greatest gift you can give to each is to take a moment to show this emotion.

Here Comes the Bride. Everyone's focus is on the bride as she walks down the aisle. Consequently, the photographer must remain in the background. Do not get in the way of the moment, but allow yourself ample space and opportunity to capture the action. It's also an opportunity to capture the faces and reactions of the guests. You should be especially conscious to capture the groom's reaction to seeing his bride for the first time.

The Vows. This is the first time the bride and groom have been face to face in close to twenty-four hours, and yet they do not have an opportunity to say everything they want to say to one another until after the ceremony. Emotions will be running high, as will the need to connect with one another. Again, keep out of the way,

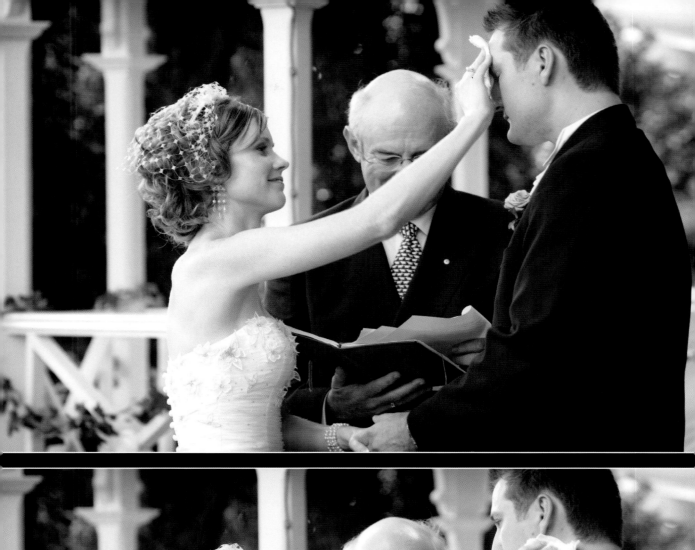
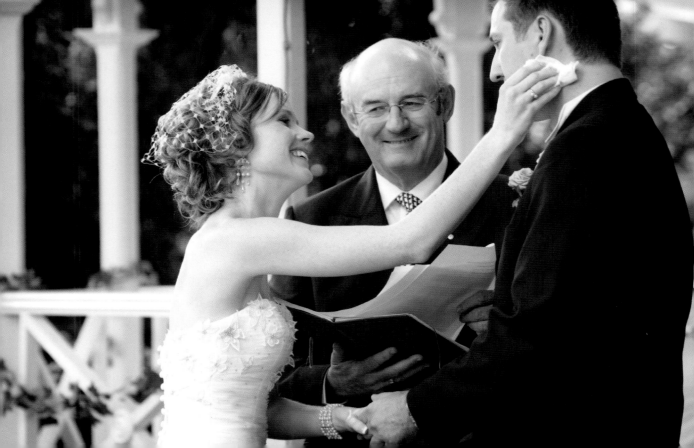

ABOVE—This little flower girl, all dolled up in her satin dress, took a moment to play in the sand, providing a real feel for the beauty of a beach wedding. There is a peaceful, relaxed feel to these types of weddings, and the little girl demonstrates this perfectly. LEFT—The placing of the headpieces in a Greek ceremony is an important part of the service. Being prepared for this moment and positioning yourself to catch it is important. Using an assistant at these weddings could free you up to watch for unexpected moments.

but allow yourself the ability to capture the moment. It's important to observe and capture subtle connections between the couple, be it the slightest touch or a special glance.

Outdoor and Nontraditional Ceremonies. When the bride and groom choose to have their wedding outside of a church or in a nontraditional fashion, they gen-

erally select a location that means a lot to them. The lack of physical boundaries spells out some beautiful opportunities to weave around outside of the guests and shoot from angles that normally would not be available to you in traditional settings.

Traditions, Culture, and Religion. Most countries have a very multicultural society and, increasingly, wed-

ding photographers are asked to capture the essence of a wedding that has different traditions than they may be used to. Research is the key to ensuring that you will catch the significant moments of the day. If the opportunity arises to photograph a wedding with traditions that are not familiar to you, consider attending a similar wedding service before your clients' wedding.

Architecture. There are some truly beautiful houses of worship around, and often these locations are selected for their aesthetic appeal or because they are the family church/synagogue/etc. of either the bride or groom. Remember to shoot a picture of the building by itself or teaming with guests before or after the ceremony; its selection as the venue was no accident.

Additional Details. There is always something going on during the ceremony, even if it has nothing to do with the bride and groom. It's important to roam the location looking for these moments to give a more com-

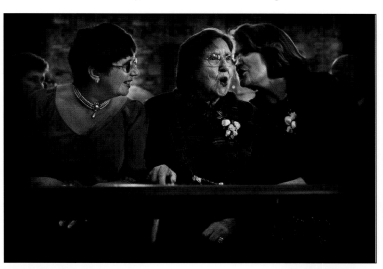

BELOW—This funky little church lent itself to a colorful, vibrant image jam packed with action. Having noticed its outside appeal and ideal location at the intersection of two streets, I waited outside for the bride and groom to exit the church and the guests to spill out onto the street and shot this complete wedding story. RIGHT—Who knows what these guests were saying to one another when this shot was taken—but I would like to think that one aunt was telling the other the story behind a beautiful detail on the bride's dress, and the other aunt was showing her appreciation.

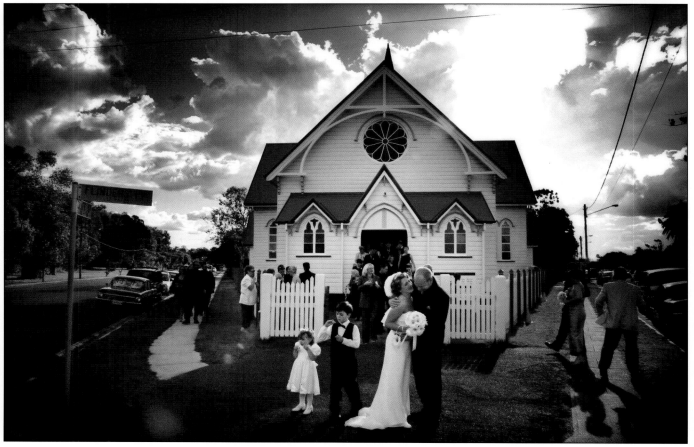

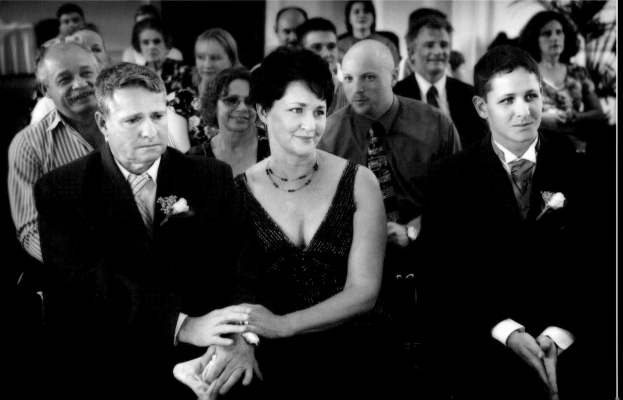

FACING PAGE (TOP, LEFT)—Let's face it, ceremonies can be boring—at least when you're four. This little boy was sprung and took a few moments out to rest and relax during this ceremony. FACING PAGE (TOP, RIGHT)—This nervous pageboy is quietly receiving instructions on what to do next. Getting down low gave the image an intimate feeling that mirrors the action. FACING PAGE (BOTTOM)—The look on this father's face and the mother's gentle expression speak volumes. The wedding day, for parents, is an emotional one—their child is fully grown and is about to embark on a life of their own. It is truly a bittersweet event. RIGHT—This image shows the shadows of the bride and her father in the archway, reaching down the aisle toward the groom. It is a wonderful example of how a different perspective can be used to capture the moment—and convey so much more. Planning and/or exploring your surroundings can enable additional opportunities that could have been otherwise missed.

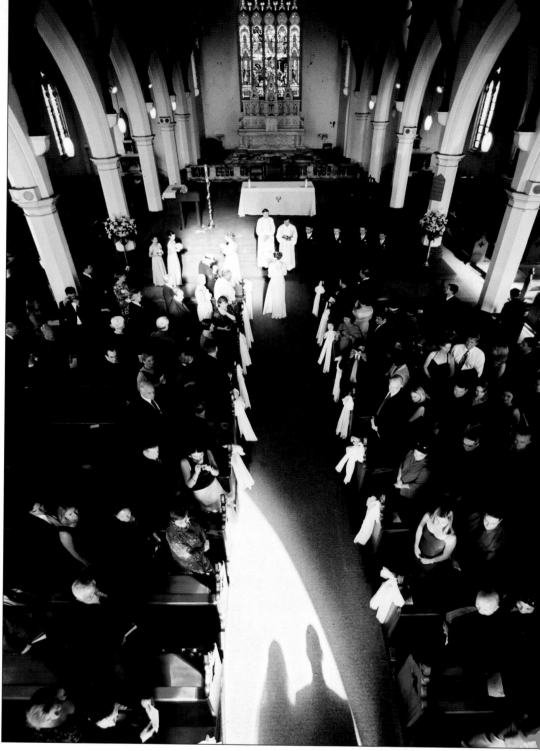

plete picture of the day. It's also important to do this unobtrusively and to choose the time to move around wisely. A great time to move is when people are standing to pray or sing a hymn.

Keep an eye on the audience during the ceremony; when the focus is off of them, they let their personalities show. There will be expressions and actions that reflect how they are feeling on the day, and capturing these is a beautiful addition to any album.

Keep an eye on the parents during the ceremony. They will be completely caught up in the moment, and the couple will love to see their reactions when they view their images.

Keep in mind that there is no better way to capture the magnitude of the ceremony than from above. To be able to capture a shot during the ceremony from this distance you will need to choose your timing. Knowing your location and the plan for the couple's ceremony

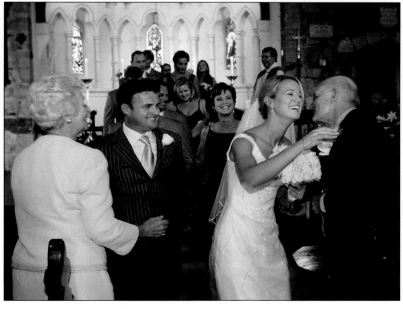

TOP—This image shows just a subtle, incidental moment at the beginning of the ceremony. Rather than just showing the musicians, however, it adds another dimension to the shot: the bride's grandmother celebrating her granddaughter's wedding. BOTTOM—This image really captures the essence of what happens as the couple exits the church. Guests will be leaning over to kiss and congratulate the couple, while the attendants happily follow behind. FACING PAGE—How much joy is written all over the faces of this striking couple? As they posed for a shot by some friends, I fired off a few frames from the side, giving another perspective to the image.

will help you choose the right moment. (*Note:* It's an advantage to obtain a copy of the order of service either prior to or when you arrive at the church so you have a timetable of events during the service.)

String quartets, singers, or flower girls scattering rose petals are some of the other little moments that have gone into creating the atmosphere of the day. Do not miss them; it's not just a special memento for the bride and groom but also a special keepsake for those taking part.

AFTER THE CEREMONY

After the ceremony everyone is happy—the hard part is over, and it is time to celebrate! You should never be busier as a wedding photographer than after the ceremony. There will be congratulations coming from everywhere, real emotion, and a spectacular high amongst everyone present. Allow this time to unfold slowly, but help keep a structure when needed. Moving quickly and unobtrusively will yield your best results. You truly must try to be everywhere at once, but keep your focus on the action surrounding the bride and groom. It's a wonderful time to capture photojournalistic portraits of the bride and groom both individually and together, as well as with family and friends.

Introducing the Newlyweds. This is the first moment that the bride and groom are introduced as husband and wife. These moments after the ceremony are precious. Be ready to capture them.

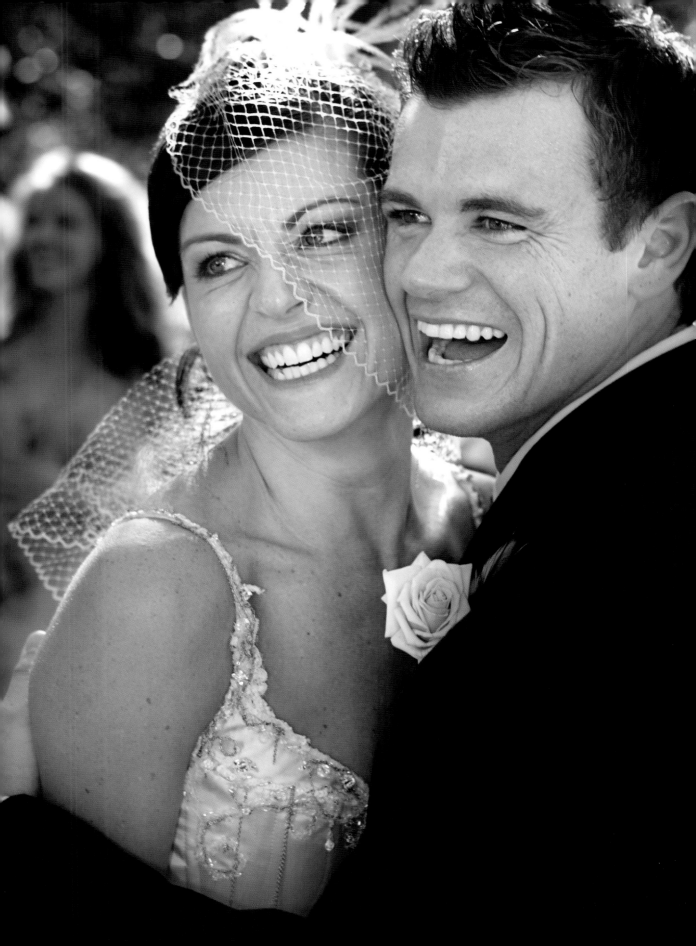

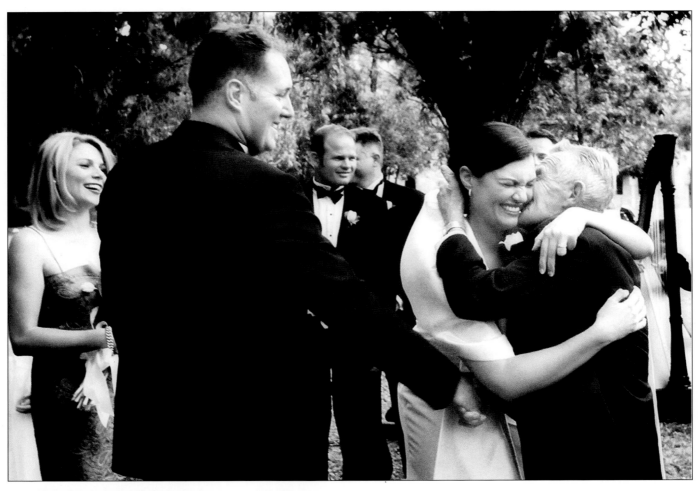

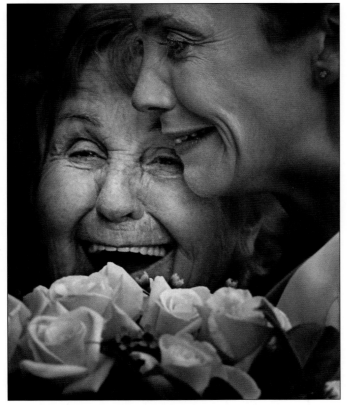

ABOVE—There is such genuine love and delight written all over this bride's face as her grandfather draws her close to plant a kiss on her cheek. A second sooner or later and that look would have passed. LEFT—Capturing not only relationships but some of the fondest moments between people is, for a professional photographer, the highest reward. An image like this is one of the most difficult to capture, but it's what encourages me to better myself at every wedding I attend.

Congratulations. Outside the church, after the ceremony is where you will find the best opportunities to show the relationships between the couple and their guests.

Love Flows. There will be many moments during the day when spontaneous bursts of affection and emotion will naturally flow. Always be at the ready to capture a shot when this opportunity presents itself.

LOCATION, LOCATION, LOCATION

Location is everything in the property market, and it plays just as integral a part in the life of a wedding photographer. Research the locations surrounding the cere-

mony venue. Know how long it takes to reach them and also have a backup plan. Speak with the bride and groom and ask if they have any ideas for location shoots and what they want to achieve. It's important to see if there is a place of special interest to the couple that you could use to add to the story. It's also important to offer your suggestions and provide your advice as a professional. Shooting at a great location in an artistic way provides a

The bride did not know that her old school friends from Korea had come to Australia for the wedding. The groom had filled me in and I was waiting for the moment when she would first see them—the first time in over ten years.

AFTER THE CEREMONY

In some parts of the world, it's uncommon to have time with the bride and groom after the ceremony to take them to a photo location. If the couple is unsure about allotting time for this, mention that it is a wonderful opportunity for the bride and groom to spend some quality time together, as well as to enjoy the company of the people in the bridal party. This is something that can be hard to do during the reception. This approach helps the couple to see the location shoot in a different light, and more often than not they allow for the extra time.

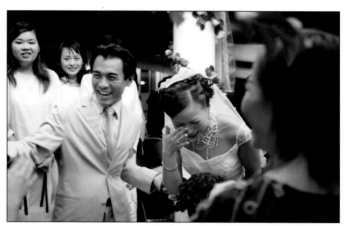

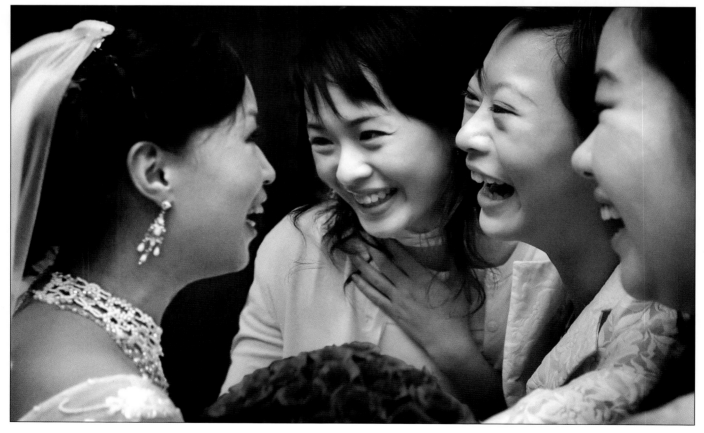

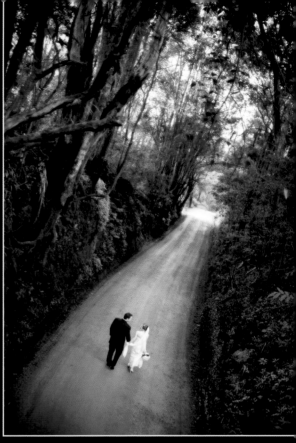

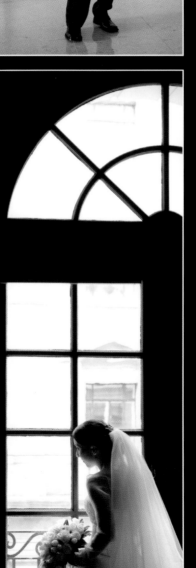

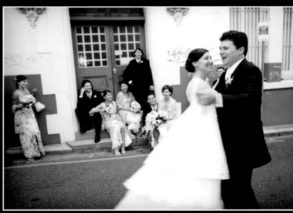

LEFT (TOP AND BOTTOM)—In these portraits, great locations are used in artistic ways to produce memorable images of the bride, groom, and couple. **TOP**—This image, created on a winding dirt road in an intimate bush setting, uses the location as a metaphor for the journey the couple is embarking on. Telling a story within an image allows the artistic component of your work to take hold. **ABOVE**—At this interesting location, I asked the attendants to take a seat as they chose. Then, I had the bride and groom entertain them with a dance. The result is fun and natural. It was more about letting them pose themselves than me taking control.

great base for wedding portraiture. When the opportunity arises, doing a pre-wedding location planning session can maximize your precious time during the actual shoot.

The Bridal Party. Wedding photography has come a long way, so rather than simply snapping the obligatory portraits (the attendants all in a line, posed with sunglasses, etc.), try to think of unique ways to capture the essence of this important group. Find interesting locations and then encourage them to have fun. Interfere as little as you can, or position the group but then allow them to interact as they normally would.

The Couple. This time after the ceremony is often the couple's first opportunity for any alone time on the wedding day, so just let them talk and embrace. Be in the background and allow them to bask in the moment. It will be a perfect opportunity for you to capture the importance of what they have done this day. Look for opportunities to tell their story. This is also a great time for the couple to share a glass of champagne together.

THE RECEPTION

More and more couples are opting to have their full reception covered. This means that as well as documenting the small details on the table, the cake and the entry of the bride and groom, the photographer will be responsible for four or five hours more coverage of the fun part of the night. There will be speeches, dancing, mingling, and moments where the guests get to spend more than just a few seconds talking to the bride and

Often, details such as the menu are overlooked by photographers. Shooting the menu from an angle allows the details to be legible, but adds a more elegant feel to the shot.

ALLOWING GUEST PHOTOGRAPHY

With the introduction of reasonably priced, quality digital cameras, many wedding photographers fear allowing guests to photograph too much. It is important to remember that the bride and groom have hired you to capture something in a way that no one else can and that how you treat their guests is as important to them as the images you capture. Allow time and access for guests to photograph without infringing on the job that you are there to do. And *always* be courteous. Some photographers fear losing their valuable reprint sales of key moments during the day (like the formal family portraits after the ceremony), but it's important to put this in perspective. Missing a few print sales in one area can be made up in many other areas. Having the respect of the guests and the couple will result in much more than the sale of a few 5x7s.

Turning the camera on the guests lined up to capture their own shots of the ceremony provides a unique and fun look at the experience.

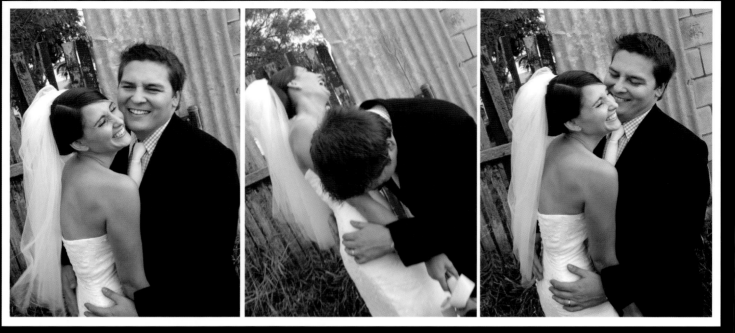

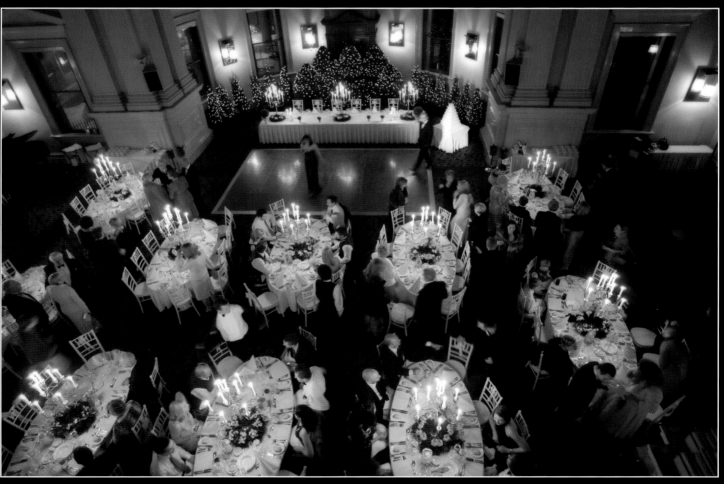

TOP—As they were elated and on a high, I was in no rush to take serious, formal shots with this couple. I allowed them their moment and shot around them. Finding a quiet, simple location first allows you to do this. **ABOVE**—If the venue allows it, try to find a place to capture the movement of the reception in one image.

Being able to bring such joy to the bridal party and guests is a wonderful reward after a day of intense focus, preparation, and image making.

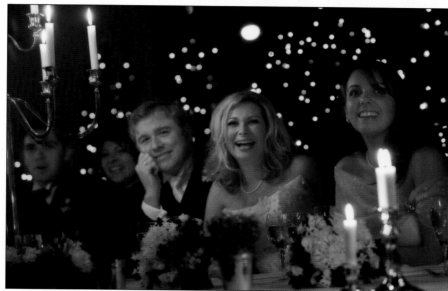

groom. There will be so much going on during this night, so remember to keep aware of what is going on around you.

Fine Details. On the reception tables you will find many different intricate details that the bride and groom have painstakingly prepared for the day. Gifts for the attendants, gifts for each other, name cards, gifts for the guests, lanterns, flower arrangements, centerpieces, and menus will be amongst these items. Find a few moments to walk around the room and capture some images before the guests arrive and their careful display has been upset.

A Slide Show to Cherish. A wonderful gift to your clients during the reception is to present a slide show of the images that were captured during the wedding day. Synchronized to their favorite songs or music from the ceremony, it becomes a wonderful highlight for all that are present.

As you can see, there are an infinite number of techniques and approaches to consider when photographing a wedding. The most important thing to take from this chapter is that there is no wrong or right in how you see the moment, but it is incredibly important to give every couple your best and strive to find something unique and important to them—as well as leaving a little of yourself in every shoot.

5. SELLING YOUR PRODUCTS

*W*hile we have spent most of the book so far discussing the more creative aspects of photography, we must not ignore the critical business aspects of the profession. As you'll see, presenting your images to clients after their wedding can be very exciting. While it's a critical step, however, it's actually just one more phase in a process that begins the very first time you talk to your client. Accordingly, we'll step backwards a bit in the timeline of this chapter, looking back to the first interview, working through the sales

Your decor should reflect you and the style you want to project. My studio uses soft, earthy colors to create a warm, comfortable feel, a simple design with minimal furniture and clutter, clean lines, and a stylish design. The studio is professionally cleaned once a week and tidied before every interview. Music always plays in the background and aromatherapy oils provide a soothing scent.

Keep things simple with plenty of storage space to avoid a cluttered appearance.

process, and concluding with the presentation of images after the wedding.

There are many selling seminars these days—more than you could ever find time to attend. Therefore, I will not spend a great deal of time reiterating the information that you can find at any one of these. Instead, I would simply like to share some tips, guidelines, and objectives that I have found to be particular to selling photography and that I have used successfully in my own studio.

DETERMINE YOUR STUDIO'S IMAGE

It is important to decide on the image that you wish to project with your studio and photography. Find your niche, what sets you apart from your competitors, and focus on projecting this image to your potential clients. You need to decide where your market lies and align your advertising and image to this demographic. Having great photography to offer your clients is a very impor-

tant component in the success of your studio; however, there are many other important elements to running a successful studio that exceeds every client's needs and expectations.

THE INITIAL INTERVIEW

When couples marry, they almost always want to document the event. They have come to you looking for the services you provide, so it is your job to show them their options and explain how each will benefit them. Every interaction with a client or potential client at your studio should be conducted according to one principle: to serve each client to the highest standard. The following should be your objectives for the initial interview.

1. Disqualify any clients whose budgets or tastes do not suit your services.
2. For qualified clients, book the wedding by the end of the interview.

Make sure the studio is always spotless, comfortable and yet warm and welcoming.

3. Send every client away impressed with the studio's services.

These aims can be achieved by:

1. Creating a great first impression.
2. Building a great rapport with the client.
3. Creating an unforgettable experience during the interview.
4. Representing the studio's services as personable with a focus on individual client care.
5. Ensuring that, during the interview, the potential client has voiced any objections they may have and will walk away without any doubts.
6. Following up with this potential client if they do not book immediately and continuing to build a relationship with them so they are more likely to book with your studio after the interview.
7. Ensuring disqualified clients have had such a positive experience with your studio that they have no reason to report anything negative in the marketplace.

First Impressions. Everyone has heard the saying, "You never get a second chance to make a good first impression." There are several components that go into making a good first impression.

First, your reception area and studio or wherever you do your client interviews need to be taken into consideration. The following are some tips on what to look for:

1. Keep your studio clean and tidy with chairs tucked in, paperwork put away, and albums (and other consultation materials) easily accessible.
2. Ensure a professional staff presentation, with all members of the team (including yourself) dressed neatly with a welcoming appearance.
3. Have music playing in the background to create a comfortable atmosphere and set the mood.
4. Evaluate what else is going on at the same time. Are there other appointments or clients being interviewed in the studio? Do they look happy?

The next thing to consider is your own demeanor. When you greet the clients, particularly if a staff member has

welcomed them before you, stand up or walk out confidently, smile, and greet them by name—just as you would welcome a friend to your home. Do not say your name before theirs; this is their wedding day and the focus should always be on them.

At the start of the conversation, it is always polite to offer your guests a drink, perhaps water or coffee. It is an opportunity to show your prospective clients your commitment to service. Pouring the water from a boutique bottle into a wine glass is a nice five-star touch.

At this stage, it is good to ask a few friendly questions, but avoid bombarding them with questions about specifics (where the reception and ceremony are, etc.) until later. Questions and comments need to be kept more general ("How are your wedding plans going?" or "It must be a very exciting time for you both.").

Directing the Interview. After you have broken the ice, you can begin to direct the interview. Begin by leading the client to where the interview will take place, and introducing them to what will happen next.

It is important that you take control of the interview early so that you can adequately explain all of the studio's services and products, as well as hear your client's plans and concerns. A great way to do this is to make a verbal agreement with the client at the beginning of the interview. This explains what is going to happen and gets the client's agreement as to the structure of the interview. This way, you can direct the appointment and present the most comprehensive overview of the studio's benefits. At Studio Impressions, our verbal agreement sounds something like this:

Thank you for taking the time to meet with me today. I understand your wedding day is extremely important to you, so what I would like to do today is tell you a little bit about our studio and our photography. Then, I would like to ask you a few questions to evaluate how we could capture your wedding day and have a look at a few options for that. I can also take you through our package and pricing options. Then you will be able to ask me any questions you have or discuss any of your ideas. Does that sound good to you?

Everyone likes to know ahead of time what is going to happen; it makes people feel comfortable.

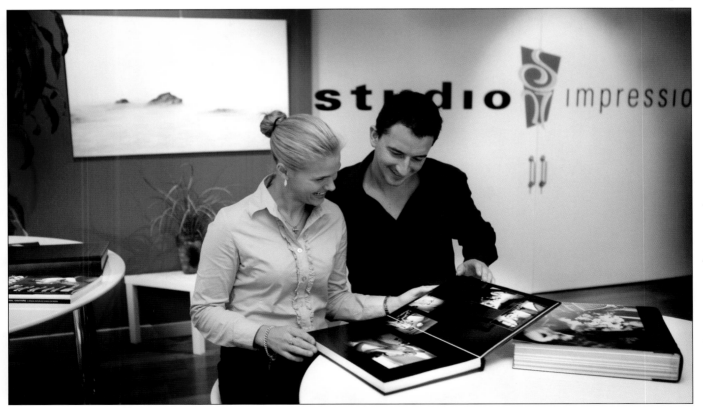

Successfully demonstrating to clients that they will receive their money's worth, both in terms of image quality and customer service, will help make them more comfortable with their investment in your product.

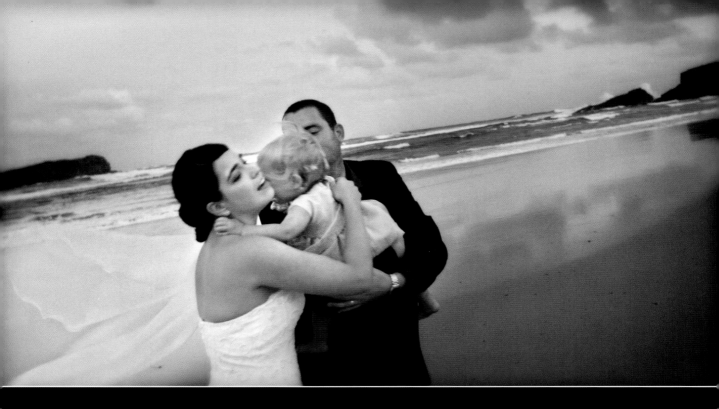

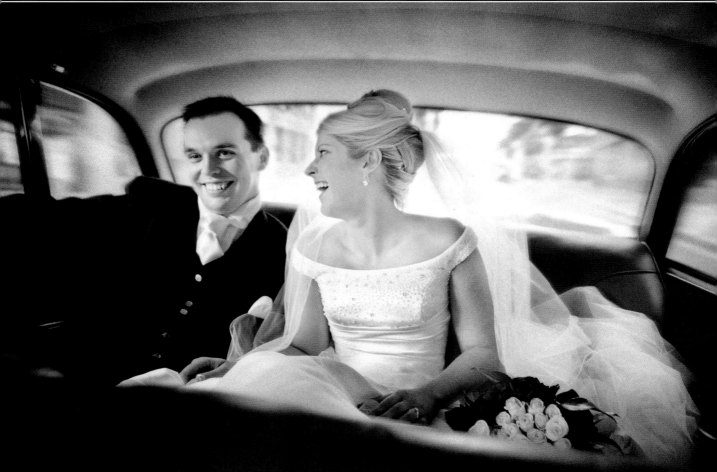

Handling Objections. Objections often scare photographers, as they have not prepared for what is often a natural part of the booking process. Your clients not only want to book a fantastic photographer, they want to book at the best price possible. An objection is the client's way of expressing that they have not yet seen complete value for their money—or perhaps they are just trying to get the best deal they can. This does not mean that you have to counter with a discount; your work is worth what you charge, and it is your job to help your client see the value in it.

The most important thing is to be honest. Do not say things that are not true. Do not pretend to know the ins and outs of another studio's pricing and packages. Instead, focus on what you do know, what *your* studio provides, and how up front you are with your costs. If you are honest and do not lower yourself to the level of picking apart your competitors, that will tell your clients a lot about your integrity.

Here are some common questions we hear and how we handle them.

Client's Question: *John Doe's work looks the same. Why is he cheaper?*
Reply: I don't know. I'm not sure how they structure their prices or packages and, to be honest, I don't know a lot about their work. The thing to keep in mind when choosing your photographer is to make sure you have all of the additional prices up front. No matter who you choose to go with, you will probably want a larger album than in the original package. Having all the additional prices up front is important so that you can budget accurately.

Client's Question: *This is a little more than we intended to spend.*
Reply: I understand it is a big investment, and everyone has their own budgets and priorities as to how they want to allocate the money for their wedding. That is why we are really up front about our costs—so

you can make the right decision for *you*. It is important to us that we make it as easy as possible for you to have exactly what you want, so we have payment plan options to help spread out payments. We also have a gift registry service so that family and friends can contribute to your photography as a wedding gift. This is a really popular option as your family and friends can help you have an incredible album, wall prints, or canvas images.

Client's Question: *Can you do a better deal?*
Response: The packages are a fantastic deal. If you were to pay separately for the photography, the album and the

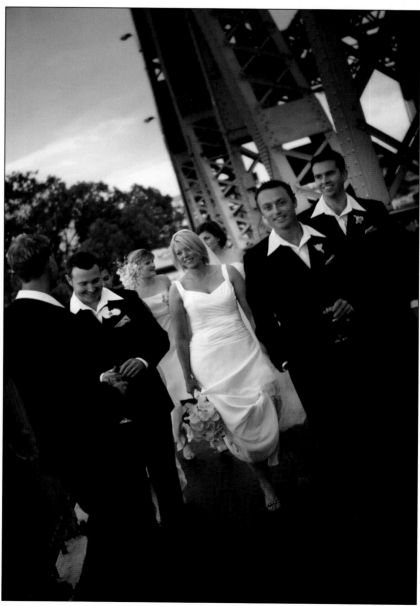

ABOVE AND FACING PAGE—Establishing a good rapport with your clients will help you to produce more natural images on the wedding day; they will feel more comfortable with you and how you work.

additional extras, you would be looking at a much higher cost. We package it so that you receive exceptional value. If you know exactly what you want, in regard to additional sides (a DVD, canvas prints, etc.), then we can try to package that for you.

Client's Question: *How much is an album going to cost?* **Response:** On average our couples spend between $5,000 and $12,000, but it is quite variable. Some couples choose to spend up to $25,000, while others go with just what is in the package. It is totally up to you and how you want to tell the story of your day.

SELLING AFTER CLIENTS HAVE BOOKED

Once you've booked the wedding, the rapport that you develop during the engagement portrait sitting, subsequent visits, and the couple's wedding day, is the foundation for the final purchases the client will make. It will also determine whether they will return to your studio for future portraits and refer you to their friends and family. The time between a booking and a wedding can be a year or more in some cases, so remember to keep in contact with your clients even when there is no business need. Telephone them to check in on their preparations, or send them a note or some information on the decisions they will need to make down the line. The harder you work at forming a genuine rapport with your clients, the easier the selling process will be. Regard your sales process as soft selling through advice, help, and education.

PRESENTING THE IMAGES

The first time your clients see their images is a momentous occasion for them. Their wedding day passed so quickly that they can barely remember much of it—and

you have captured many moments that they did not even know happened. They have returned from the honeymoon rested and relaxed and are very ready to see their wedding images. There will be many emotions flowing and you want to make this moment as special for them as you can. Take time to prepare the studio for this event. Adjust the lighting, provide comfortable chairs that make it easy for the clients to view their images, and have plenty of tissues on hand.

The cocktail viewing has been a fantastic success for Studio Impressions. This is an opportunity for the newly married couple to invite their friends and relatives into the studio to view their images with them. It is always a very happy occasion, and providing champagne and finger foods adds to the festive atmosphere. The cocktail viewing allows friends and family the opportunity to discuss options to purchase images, parent albums, framing, and multimedia options. It also introduces guests who have seen you at work to the finished product you have created—and word of mouth is always the best advertising.

While couples at Studio Impressions will first see their images in the projection room, they are able to do their image selection in a welcoming, comfortable part of the studio. This is done at our viewing station using a 32-

Having a large projection screen really allows the couple to become emotionally involved with the images. Adding music will also help to move them back to the day and remember it as it happened.

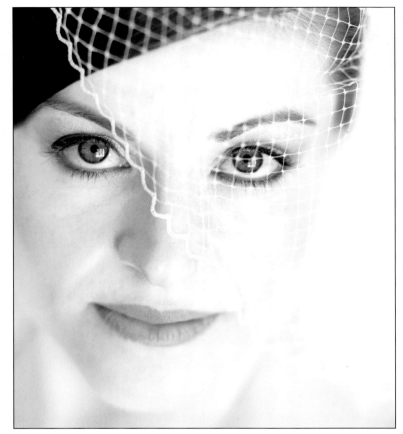
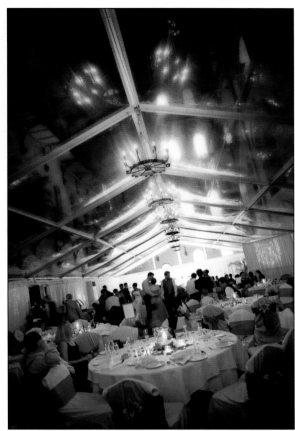

Beautifully crafted wedding photographs are works of art and deserve to be valued, presented, and displayed as such.

inch LCD screen. The couple has plenty of time to go through the images at their own pace and in private. Little touches like a waiter delivering a cappuccino from the Italian café situated above the studio or ordering a piece of cake from the menu we place next to the screen will also highlight attention to detail. Having a dedicated viewing area has certainly enhanced our clients' overall experience.

ADDITIONAL TIPS FOR SELLING

The mere thought of selling is enough to strike fear into many photographers, but the process need not be negative or complicated if it is approached with the right attitude.

Provide Honest, Professional Advice. I am not a fan of the hard sell, an approach that has given more than a few photographers a bad reputation among consumers. The right approach to selling your photography is to be honest, open, and provide professional advice. Your client has come to you for a product and they need you to advise them on the best way to get it. You will be surprised how receptive they will be to your ideas if you

have established a solid relationship and excellent rapport. If the client does not trust you completely, however, your advice will lack believability and they will not act on your suggestions.

Provide advice on what you would love, what you would purchase for your own collection, or what you have would hang in your house. Explain that this is what you personally believe. Your clients will pick up on the honesty of your recommendation. Remember that they have come to you as an expert in your field, just as they would a doctor or lawyer, and they want your professional opinion.

PROSELECT FOR CLIENT VIEWINGS

ProSelect is a valuable program for the studio, as it has many features for both wedding and portrait clients. One of the major advantages to ProSelect is its ease of use and the ability for clients to quickly sort their wedding images into their favorite piles. Using this software, clients can quickly categorize the images into three folders: "yes," "maybe," and "no."

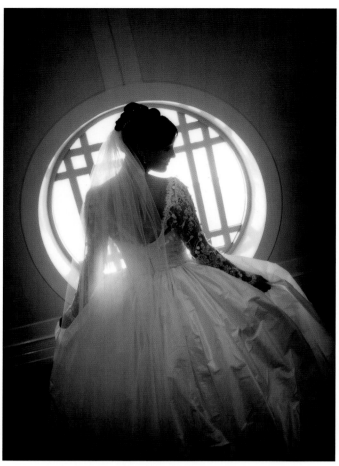

When pricing your images, don't fall into the trap of thinking you are charging for a piece of paper with an image on it—you're charging for everything it took to get the image there (your equipment, education, etc.).

Sell Your Work as Art. If you approach your work from an artistic standpoint, you are truly producing fine art—and that's how you should sell your work to your clients. Build in them an appreciation for the skill, emotion, and years of training and practice that have gone into producing their images. Use artistic terminology when speaking about your work and show them your range of art products. Defining and presenting your photography as art will add value to your product.

Showing Clients the Value of Photography. When a client is hesitant to book, money is not always the issue, it also has a lot to do with the experience, the service, and the product—in this order of priority. In many cases, your clients will not have had much previous experience with professional photographers. It should, therefore, be part of your service to educate them about the art that you produce, your prices, your product range, and the value they will receive for their money.

Offer Prepurchase Options. It will work to your advantage to offer clients the chance to prepurchasing some of your products. You know that the album you are going to produce for them will be a classic work of art and that they will want every image you took to appear inside it. So, offer them the opportunity to purchase additional sides, framed prints, art books, and other products prior to the wedding for a special price. This will ensure that they have budgeted for the products they will eventually desire.

This is the only time we reduce our prices, and it is only to educate our clients. This lets them know that the album can be as large as they like, and it's possible to package a larger album prior to the wedding.

When you are showing clients your additional products, be sure to make a note of what you have shown them so that you can introduce *new* products next time and avoid repeating the process.

Pricing. How to value your products is one of the toughest decisions for a professional photographer to make. It sometimes requires you to step outside your comfort zone to truly appreciate all that goes into your work. Time and time again, I have had to search deep inside and remind myself of everything I have achieved, the years I have spent becoming the photographer and businessman I am, and believing that this was not a fluke. Success may come to those who have not earned it, but they rarely keep it. Only those who have earned their position retain success in the long run. You need to believe in your own talents, abilities, and possibilities.

Be your own best friend in this regard. If you believe your photography is worth X amount of dollars you could actually double it; generally photographers undervalue themselves. With photography, you can achieve any price for your product—prints in galleries, for instance, can be purchased for anywhere from $50 to well over $100,000.

Never forget that you are not pricing for a piece of paper with an image on it. You're pricing for all the things it took to get that image on the paper—years of training and practice; overhead to run, staff, and advertise your studio; camera, lighting, and computer equipment; and much more.

6. CREATING A MASTER IMAGE

*C*reating an art quality print requires more than just being a great photographer. An understanding of professional equipment, tools, and software, as well as both traditional and digital printing techniques is essential if a good photograph is to be considered a master print. There are four essential steps to creating a master print: having direction and vision; creating a great base; applying your vision and shaping your print; and producing and printing your image.

THE BASIC MIND-SET AND PRINCIPLES

Although most photographers have abandonned the traditional darkroom in favor of a digital workflow, retaining the goal-oriented, problem-solving mindset of the darkroom printer is still critical. With digital, photographers often fall into the trap of just experimenting with an image until they stumble into something that looks okay. While this may occassionally produce acceptable results, it will rarely lead to the creation of a truly flawless, fine-art print.

A truly beautiful image doesn't just happen, it requires careful planning and well-honed technical skills—both before and after the shoot.

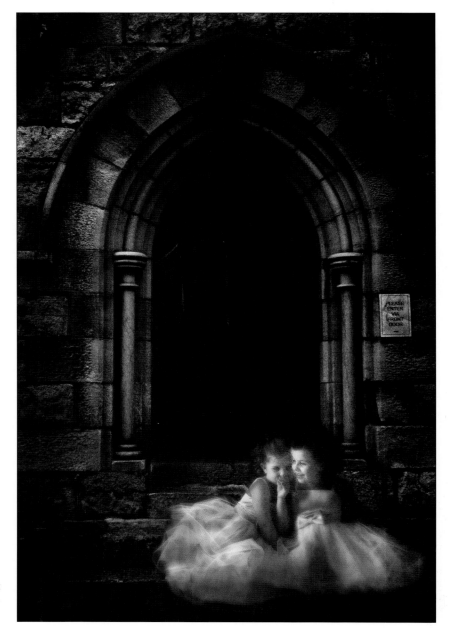

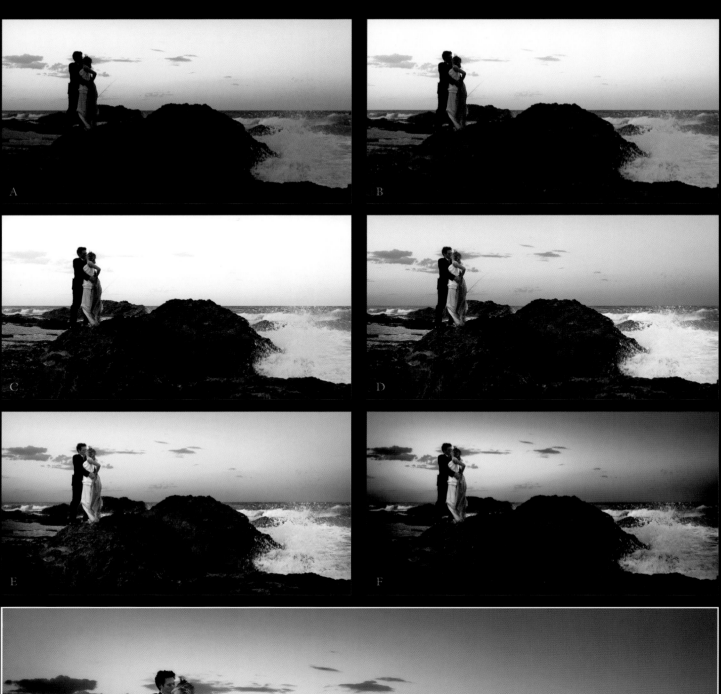

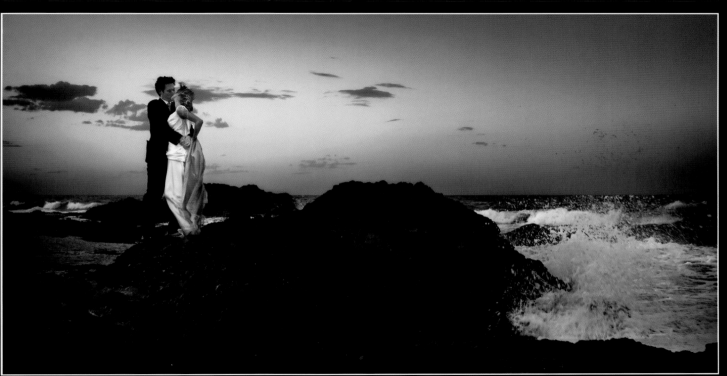

FACING PAGE—The image on the facing page shows the importance of talking to your clients about what they do. It came up in conversation that the couple went to this place every afternoon after work. It was their place to dream. We decided to use that location in their wedding images.

To create the final image in this series, the following steps were employed. The couple was chosen as the center of interest and their joined bodies were highlighted to create impact.

The first three frames are three different RAW conversion exposures: A for highlight areas, B for the midtones, and C for detail in the shadows. Frame D shows a mixture of the three previous images, giving maximum detail in the shadows, highlights, and midtones. This provided us with a new master image from which the final image could be shaped.

In frame E, I removed the fishing rod coming out from behind the bride and groom and the man standing there. I also molded the rocks more and brought the detail down into the water. In frame F, I vignetted the image, darkened it, and brought out the colors more. In the final frame (bottom), I further shaped the rock detail and lightened the bride and groom so they became the lightest part of the image.

When printing in a darkroom, on the other hand, it is necessary to carefully consider the final image that you wish to produce and carefully think through the steps required to create this image—*before* you get to work. For example, in a darkroom setting you would have to make several decisions before you even placed the negative in the carrier—what paper to use; if softening was needed; what areas of the image to dodge and burn; if the print would be toned; if the color needed to be warmer or colder; and much more. As you can imagine, approaching your images in this way leads to much more carefully crafted results.

The following criteria should be evaluated, therefore, when setting out to produce a master print. Here, we will look at these factors in relation to traditional media. The digital application of these darkroom principles and techniques will be covered when we discuss shaping an image.

Exposure. An image requires a good exposure before any other techniques can be applied to enhance the image. Before working on a print you must examine the exposure. This is usually done by examining the white zones on the negative and ensuring that the exposure is long enough to bring out the texture and detail within the white zones, but not so long that they look gray. Correcting exposure digitally is so much easier than the testing and retesting required in a darkroom situation, however the principles of ensuring a suitable exposure remain the same.

Dodging and Burning. Dodging (decreasing exposure to lighten an area of the print) and burning (increasing exposure to darken areas of the print) draws the eye of the viewer toward your center of interest. The use of dodging and burning is dependent upon the mood you wish to create within your print. This technique can be a highly effective way of adding depth to an image, but it can also be overdone and act as a distraction. Planning is key to applying effective dodging and burning techniques.

Contrast (Paper Grade). It is important to have a good contrast range in your image. A great photograph has a range of contrasting colors (or grays) from white to black; this creates depth and interest. In the traditional darkroom, paper selection can have an impact on contrast. To improve contrast range you can use a higher contrast paper. Lower grade papers will provide lower contrast and a "flatter" image, which for some subjects produces an interesting result.

Color. There are three elements of color that must be understood to create a master color image: color balance, color saturation, and color tones.

Knowing how to balance the primary colors of red, green, and blue to improve color in an image is essential to producing a master print. Too much or too little of any one color can change the mood of an image, so careful thought should be put into color balance.

The brightness of a color in a print can also impact the mood of the image. Taking time to work on the colors, by either increasing (brightening) or decreasing (dulling) their saturation, can assist a photographer in expressing his or her message.

Some images take on a new life when printed in color tones such as sepia or blue. Experimenting with different tones can often result in the emergence of a new image.

Grain. The grain evident in a print was once dictated by the film used to shoot the image. Digital technology has now made it possible for grain to be added to or removed from a print in order to achieve the effect desired by the photographer. Adding grain to a print can add texture and life to an image. I find this an especially useful tool when my image is composed of a vast landscape.

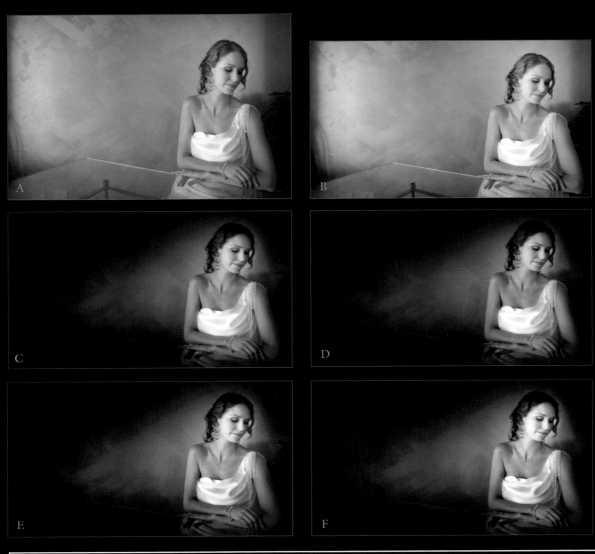

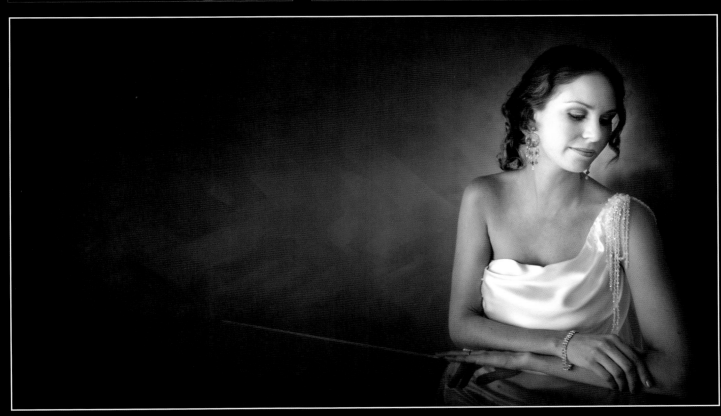

FACING PAGE—In this series, frame A is the initial captured image and frame B shows the shot after I converted it to black & white. In frame C, you can see that I applied a heavy vignette and lightened an area to improve the composition of the lighting. Frame D shows how I rotated the image to evaluate the print. Notice how your eyes are still immediately drawn to the lightest part of the print. Because the the dress was overpowering the bride's face, I brought down the detail of her dress (frame E) and, in frame F, lightened her face. The image was then toned (bottom); this is the final print.

HAVING DIRECTION AND VISION

To create a great photograph you need to make some important decisions at the start of the process. These initial choices will determine, to a great extent, the success of your final print.

Center of Interest. What is your center of interest? Consider your print and choose the element that you wish to highlight to the viewer. When you first look at an image, your eye will be drawn to the lightest part of the print, therefore your center of interest should ideally be within this area. If your eye is not immediately drawn to the center of interest, the area around the subject may need to be lightened to draw attention to it. Distracting areas may also need to be darkened. (*Note:* The subject does not need to be the brightest part of the image, but the immediate area around it should be.)

Impact. Consider the effect that you would like to have on the viewer of your print. What feeling are you trying to create? Is it a sense of drama? Romance? Lightheartedness?

Composition. Consider how all the elements of the print work together. Allow the viewer's eye to be led around the print. Use composition to lead the viewer back to the center of interest or out of the frame.

Create the Mood. Think about the mood you wish to create with your image. What do you want your viewer to feel? You can apply many different tools and techniques to emphasize the mood or feeling you would like to communicate with the image.

Understanding the different types of techniques at your disposal is critical to planning how you will create the mood you are seeking in your image. These will be covered in detail later in this chapter.

CREATING A GREAT BASE IMAGE

Once you have solidified your vision, you have to establish a solid base image for the print if you want to create something special. This will be the foundation for your final creative enhancements.

There are four steps involved in creating a great base for your print. The following section describes the approach.

Check the Exposure. First, examine the exposure. Look for good detail in the shadows, midtones, and highlights. If the image has been shot under well-controlled lighting conditions and you find you have great detail in all areas, you are ready to procede.

Due to severe lighting conditions or exposure error during capture, it can sometimes be difficult to obtain a single good exposure that gives detail in all areas. If this is the case with your image and you have shot it in the RAW format (if possible, bracketing your exposures), you may still be able to recover detail in these areas—though to a limit. To obtain the most detail in all areas of the image you will need to do a separate RAW conversion for each range of the image. That is, convert for

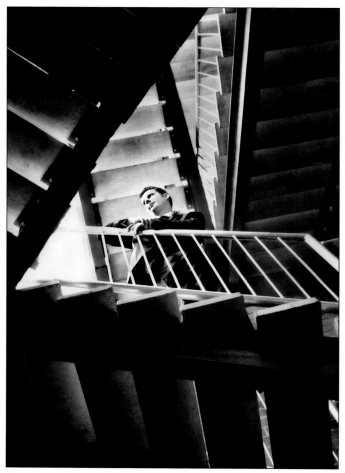

Creating prints that contain a full range of tones, from right blacks to brilliant whites, while maintaining detail in all the critical areas requires solid technical expertise.

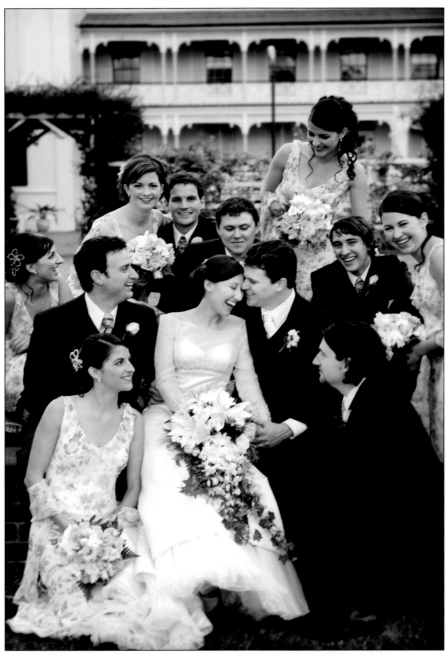

sible, such as Adobe RGB (1998) for conversions done in Photoshop ACR, Capture One, or similar programs. I recommend Capture One to process your conversions, due to its advanced processing power.

Create Layers. Combine the various exposures into one file using layers in Photoshop. To do this, drag the shadow-detail image, highlight-detail image, and any other conversions onto the midtone-detail conversion file. This file will act as your base and should be on the bottom. Holding down the Shift key while dragging the files will center the images for you.

Once you have all your conversions/exposures in one file, create a layer mask for each conversion. It is important to invert the layer mask so the layer mask is black. In its current form, this will have no effect.

Additional Shadow Detail. Shadows can occasionally be difficult to optimize in RAW conversions. It is possible to improve shadow detail using the Shadow/Highlight tool (Image>Adjustments>Shadow/ Highlight). Make alterations on the layers by inverting the layer mask to white so you can see the effect and selecting the areas requiring additional detail. Then adjust the difficult areas.

Applying Detail. Working in layer masks, determine the highlight and shadow areas where you need to bring back detail. There are two main methods for control the detail using the layer mask:

1. *Use the Brush Tool.* As a guide, set your foreground color to white, your background color to 50 percent gray, and use the Eraser tool as your black. Press "X" to switch between the foreground and

shadow detail, then midtone detail, and then highlight detail. Occasionally you will need to do extra conversions for areas with a wide variation within each tonal range.

If the image was not captured in RAW mode but as a JPEG, it is still possible to use this method by adjusting the file using Curves, Levels, and Shadow/Highlight recovery, and combining the different exposures in Photoshop. Be sure to save a separate file once the JPEG image is converted to a TIFF for editing.

Finally, it is important to convert files into 16-bit file formats. You should also use the largest color space pos-

background colors. Paint with white to completelly reveal the masked detail on the layer. Paint with gray to partially reveal the masked data. Paint with black (i.e., erase) to conceal the data and reverse parts that you accidentally applied.

2. *Use the Lasso and Marquee Tools.* Select the desired area on the image. Feather and perfect the section using the Quick Mask mode. Then use the Fill command (Edit>Fill) to fill the desired area with white, gray, or black. To fade the effect by changing its opacity or blending mode, go to Edit>Fade.

Using layer masks enables you to return to the image and alter applications at a later date if required. You are able to accurately select the areas that require additional detail and apply this in each additional level.

Save the File. Save the file in its current form (including layers) as a PSD file (Photoshop document). Saving this file may take a few minutes; at this point, it will be quite large. While you may not necessarily continue working on this file in layered form, it is beneficial to have a record of each layer in case you need to return to

the image. For example, you may wish to return to a prior form of the image if you have lost detail or some other element within the image as you progress. By saving the file and all layers you will save time in later stages should you wish to adjust the image from a previous state.

Flatten the Image. To reduce the file size from the one you have saved in layered form, you need to flatten the image (Layer>Flatten Image) and save it as a TIFF file to avoid loss of image quality. This flattened image will become your "negative."

At this point, rather than flattening image, you could also create a layer set of all the layers still containing their layer masks. You can then make changes to the file over all the layers at once. The image is still able to be duplicated as normal, because you duplicate the layer set. This approach takes a lot of computer memory because your file sizes multiply each time you duplicate the image set, so I prefer to flatten the image.

Noise Reduction. If you find the the image contains too much noise, it should be reduced at this stage. The best results can be achieved with a dedicated noise

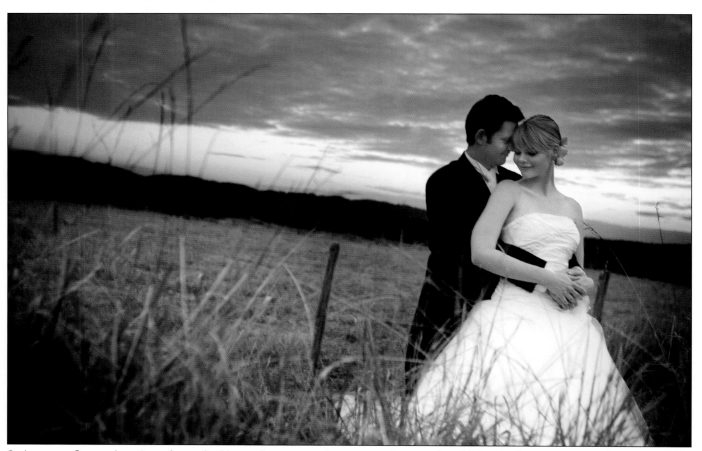

Saving an unflattened version of your final image leaves open the opportunity to make additional adjustments as needed.

reduction program/plug-in like Noise Ninja. If using Noise Ninja, it is important to apply your camera profile at the ISO setting used for the capture. Noise-reduction profiles can be downloaded directly from the Noise Ninja site (www.picturecode.com), or advanced users can create their own profiles. Save the new file with a name that indicates that the noise filter was applied.

Remove Dust and Distracting Elements. If you find small spots on the image (produced by dust on the camera lens) or other distracting elements such as hot spots, blemishes, and imperfections, remove them using the Patch or Clone Stamp tool.

Capture Sharpening. You may find that the RAW image is a little soft. For best results, I like to use the Photoshop plug-in Photokit Sharpening. If you prefer another method, however, you can apply it at this time.

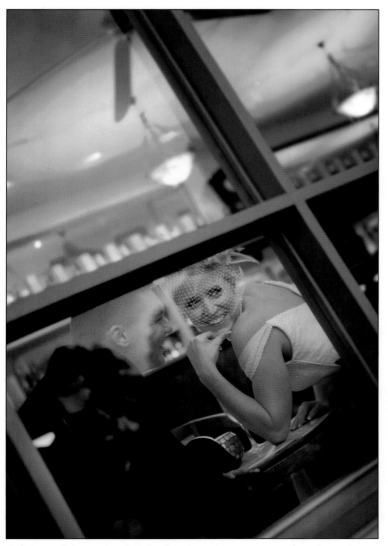

Once you have created a flawless base image, you are ready to begin sculpting the print to achieve your creative vision.

You have now created the base image for your master print, a perfect canvas to create your masterpiece. Your image is still in its infant form, of course, but all the detail you need to create a great image now exists.

APPLYING YOUR VISION AND SHAPING YOUR PRINT

The next step is to shape your print using techniques that will help you turn your base image into the image that you had visualized at the start. Having an understanding of the darkroom basics discussed earlier in this chapter is of great benefit at this stage of the process. In this section we will show how some of those darkroom techniques can be applied to shape the print and create the final image.

To begin, duplicate your base layer and turn off the bottom background layer. The bottom layer is not to be altered (except if you clone or remove any parts of the image). Some basic digital darkroom principles and how to apply them when shaping an image in a digital context are discussed below.

Exposure. Tools such as Curves or Levels can be used to change the global density of the image. Using the Curves is the best option and the only way to retain all the information in your file. Never use the Brightness/Contrast command; this produces a significant reduction in highlight and shadow detail. If an image is too punchy or has too much contrast, adjust the Levels at the start of the process, then use other tools to alter the overall exposure. A final Curves or Levels adjustment may also be performed prior to printing depending on the choice of photographic paper.

Dodging and Burning. While it may seem logical to do so, I do not advocate the use of the Dodge and Burn tools. Better effects can be achieved using other methods.

For example, the same effects can be created by duplicating layers and using blending modes like Multiply and Screen. You can select the areas where you want to apply the effect by using layer masks or simply by erasing areas or deleting selections that you do not want to change. You can also adjust the opacity of each layer.

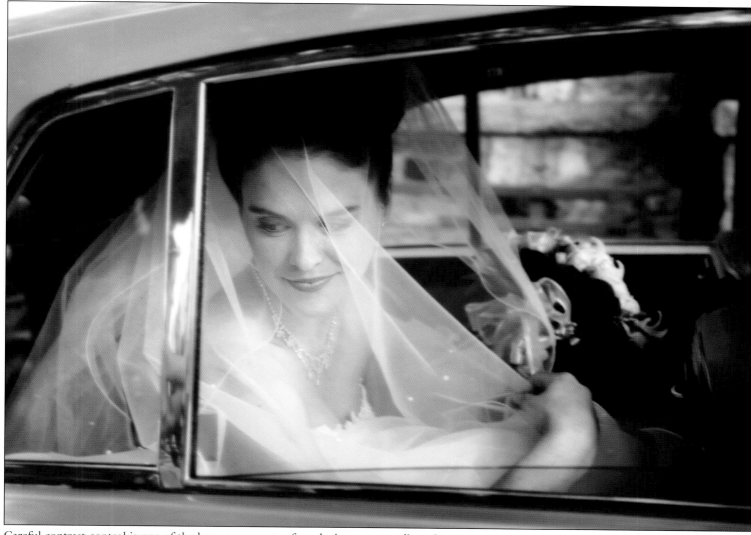

Careful contrast control is one of the key components of producing a top-quality print.

Dodging and burning effects can also be created using the History Brush to apply data from one history state (flagged as the source in the History palette) to the current history state. You can change the mode and opacity of the History Brush in the options bar at the top of the screen to control your results.

You can also use the Levels or Curves tools to alter the density on selected areas. These tools can also be used in partnership with the History Brush.

Finally, the Shadow/Highlight command (Image> Adjustments>Shadow/Highlight) is a useful tool to pull out shadow detail (essentially dodging). Simply select the area and alter its density as needed. Be careful of halos when using this approach, however.

Contrast. Contrast can be altered digitally using a few different methods. You can simply adjust the Levels or Curves. You can also apply blending modes like Soft Light, Hard Light, and Overlay to duplicate layers.

Color. Color can be a fantastic tool to enhance and highlight your center of interest. Shaping your print requires a consideration of all the elements of color. Many tools can be applied to adjust the color in an image. In Photoshop, most of these are found in the Image>Adjustments menu. Note that the effect of each tool can be altered immediately after applying it by going to Edit>Fade and adjusting the opacity and/or blending. Color fill layers (or even other images on their own layers) can also be applied using various blending modes to adjust the color.

The first thing to consider is the color balance in the image (the balance of the primary colors of red, green, and blue). This can be altered a number of different ways—adjusting the individual color channels using the Curves or Levels commands, for example.

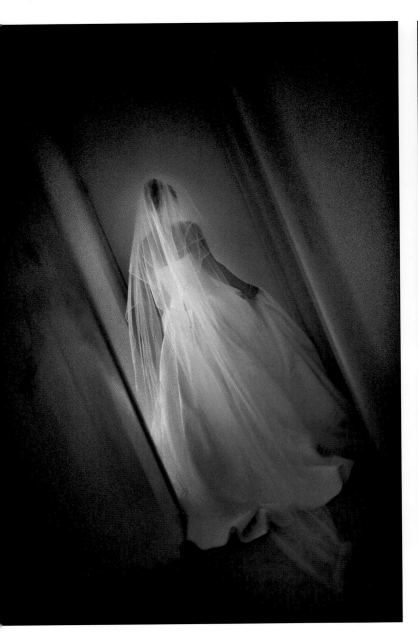

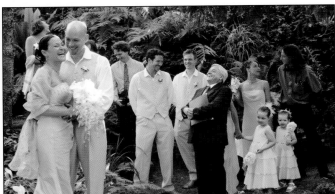

Controlling the hues and saturations of the colors in your images is a critical component of crafting a breathtaking print.

To adjust the color saturation in a print, use the Selective Color command, layer blending modes, or the Hue/Saturation command. Using Hue/Saturation (Image>Adjustments>Hue/Saturation), you can change the saturation of the entire image at once or adjust individual colors only. You may also wish to produce your image with color tones, such as sepia or half-tone effects.

Black & White. Many images are actually most effectively presented in black & white. Black & white can also, in some instances, express a mood or emotion more effectively than color. There are a number of plug-ins available to stream-line this conversion, or you can simply use Photoshop (consult any basic book on Photoshop for the options available).

Selective Softness. To soften selected areas of an image you can use a combination of the Gaussian Blur filter (Filter>Blur>Gaussian Blur) and layer blending modes. Take care not to blur an image excessively and be aware that softening can create halos around a subject, reducing the integrity of the image. To reduce edge halos, work on duplicate layers and use the History Brush or layer masks to eliminate problem areas.

Grain. Grain in the print can help create mood. To produce a grain effect, do the following:

1. Open your base image and create a new layer.
2. Fill the layer with 50 percent gray (Edit>Fill).
3. Apply the Add Noise filter (Filter>Noise>Add

Noise) or Film Grain filter (Filter>Artistic>Film Grain).

4. Desaturate the layer (Image>Adjustments>Desaturate).

5. Change the layer blending mode to Soft Light, Hard Light, or Overlay as needed.

6. Change the layer opacity to produce the desired effect.

7. Save the file with the noise layer intact as a PSD file.

Sharpness. When preparing the corrected base image, we already applied capture sharpening to the overall image (see page 90). To selectively improve the sharpness in your image, use the following procedure.

1. Open the base image and duplicate the background layer (Layer>Duplicate Layer).

2. Apply the High Pass filter (Filter>Other>High Pass) with the Radius set to 10.

3. Change the layer blending mode to Overlay or Soft Light.

4. Create a layer mask and invert the image (Image>Adjustments>Invert).

5. Using the Brush tool, paint on the mask (with white as the foreground color) in the areas where selective sharpening needs to be applied.

6. Adjust the layer opacity as needed to produce the desired effect.

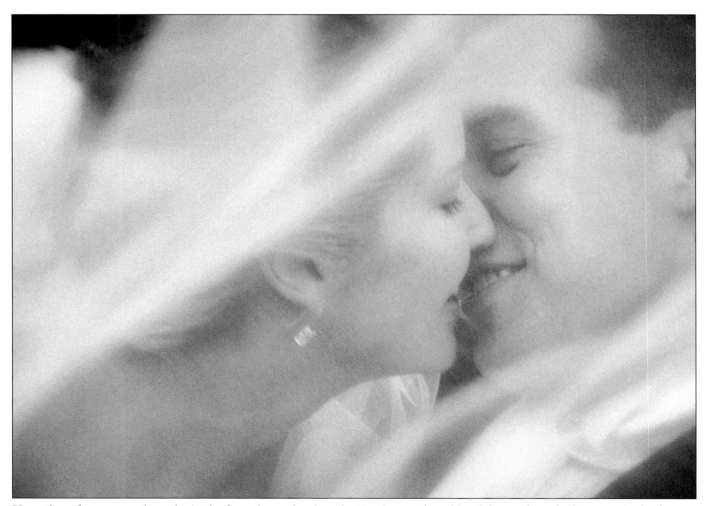

Here, the softness everywhere else in the frame keeps the viewer's attention on the subjects' faces—the only sharp area in the frame.

7. PRINTING AND PRESENTATION

Once you have applied your chosen techniques and are happy with the final image, you are ready to produce a master print. Great images can be spoiled through the use of poor printing techniques. While a complete treatment of color management and the intricacies of digital printing falls beyond the scope of this book, the following are some important factors to keep in mind.

PRINTING

It is now possible to produce world-class images in house—prints that will hold their own against any other form of printing available today. To achieve this quality, your studio needs to have the latest, top-quality equipment and—more importantly—a complete understanding of color management. While the convenience of producing prints in-house is appealing to most, establishing

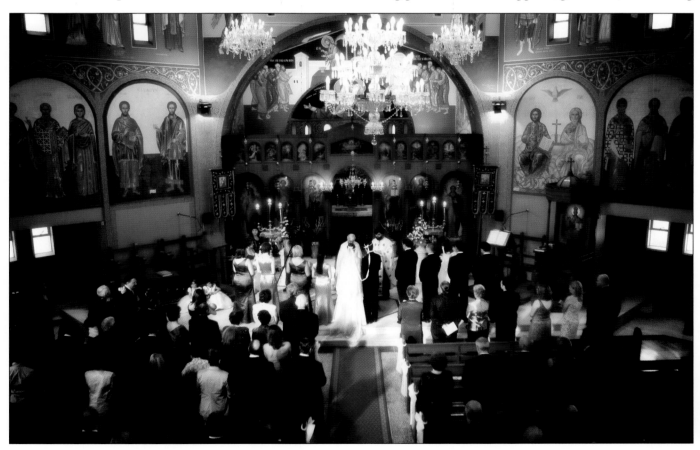

Prior to printing, it's important to add a little bit of sharpening. How much is needed will depend on the print medium you choose.

such a solution may not be feasible for some studios. In that case, you can outsource your printing to a professional lab that uses state-of-the-art printers and color management.

Output Sharpening. Prior to printing, you need to apply a degree of image sharpening to adjust the image to the type of print medium selected (see below). To do this, apply the Unsharp Mask filter by going to Filter>Sharpen>Unsharp Mask and using the following settings: Amount—120; Radius—0.8; Threshold—0. Then, go to Edit>Fade and set the mode to Luminosity.

Add Noise. The last step before printing is to add a hint of grain using the Add Noise filter (Filter>Noise>Add Noise). The Amount setting should be from 0.5 to 1 percent, depending on the size of the print. This should create just a hint of grain when viewing the print at full size.

Soft Proofing. It is also important to soft proof your images to identify any limitations in the paper that you are about to print on. If necessary, you can then adjust the image prior to printing to ensure the best possible results. Because it allows you to quickly preview multiple papers, soft proofing may also reveal that a paper other than that originally selected will actually provide a better rendition of the color gamut and tonalities.

Selecting Your Print Medium. To ensure the production of a master print, you need to consider your print medium. Some popular printing papers and techniques that I offer my clients (and that you should explore) are fiber-based printing, watercolor paper prints, and metallic prints.

The medium you select for your print will have a direct effect on the "feel" of the final image and its

Simple, classic images like this—especially when expertly printed and presented—will truly stand the test of time.

longevity. It can add to or detract from the mood of your print and enhance or bury subjects within the image. For this reason, considerable thought should be given to the print medium.

Keep in mind that most clients will not understand their options, so it is your responsibility to help them make an informed decision. Giving your clients this choice means that you can establish a price range in relation to quality. It also gives you the ability to produce works that you are proud to sell and to achieve a price worthy of your art.

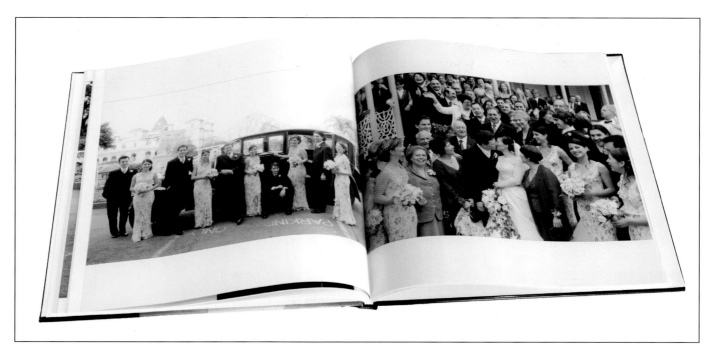

PRESENTATION BASICS

The next step is to present your image in a fashion that is suitable to your studio's style and your clients' tastes. The way you present your images can increase your client's perception of the quality of your work, and thus increase the value of your product. This is crucial to your customer satisfaction and sales.

Now more than ever, professional photographers need to differentiate themselves from the consumer or amateur photographer market, creating a quality distinction that will keep them in business. Being able to pro-

The ability to produce high-end products is one of the factors that sets professionals apart from amateurs.

duce premium products is also critical to achieving this goal.

Research. Inspiration can come from the past as well as from predicting future trends. One great source of insight is the work of interior designers and high-end furniture designers/retailers. You can also look at the latest movies, television shows, and upscale lifestyle magazines. These reflect the current design trends and methods for displaying artwork in the home. When you visit your friends, family, and clients, keep an eye on what people currently have in their homes.

Museums and galleries are also an excellent source of research for the professional photographer, as they often showcase the cutting edge in artistic presentation. If possible, consider talking to the curators and tapping into their wealth of knowledge.

The Test of Time. When a client invests in a commissioned work, it should have an unlimited life-span. Therefore, it's important to avoid fads when selecting products to add to your line—ask yourself, "How will this look in ten years?" Typically, the best longevity will be achieved when you avoid completely new products and select, instead, designs that are simple and classic (or refreshed versions of classic designs).

Another important consideration is quality. The best products exude quality and professionalism. Imagine the

disappointment a client would feel if they purchased a substantial amount of work from you and then discovered that the same products could have been produced at the mini-lab in their local electronics store!

Additional Products. There is definitely space for products that help promote you and your studio, like DVDs, wallet photos, and thank-you cards. It is important, however, that these are produced with the same attention to design and quality as your main products.

Another important product to consider is multimedia presentations—a very powerful medium when used successfully. Personally, I feel it is still important to have a printed masterpiece. Therefore, I stress to my clients the importance of the printed image and offer the multimedia product as a complimentary product rather than the primary or sole one. Imagine experiencing the *Mona Lisa* only in multimedia form and missing out on the experience of standing in front of it yourself and experiencing the subtleties of the painting. It's important to

BOTTOM LEFT—Our DVD product is not available to everyone who has booked a wedding shoot with Studio Impressions. Only clients who have purchased a particular level of package have the option of purchasing an interactive DVD that is set to the music of their choice. BOTTOM RIGHT—Thank-you cards are an expected offering for any studio these days—and an excellent way for you to market your services to friends and family who have already seen you at work at the wedding. RIGHT—The classic gallery print can be displayed on your client's walls in a series or individually. Show them examples of how their images can look on their walls at home and suggest possible sizes, styles, and hanging options. Using a projection system can show a client exactly how a series of images would look hanging together. It's also a good idea to have on hand images of designs that you have created for previous clients.

educate the client about the advantages of a finely crafted print, pointing out the subtle tones and colors that bring a unique and powerful dimension to each image you produce. It's these qualities that they will appreciate for a lifetime.

FINE-ART PRODUCTS

The Classic Gallery Print. The classic gallery print has become an icon of our times. These images can be found in just about any gallery worldwide and are equally at home decorating the walls of set designs in movies and popular television shows. A classic gallery print never looks out of place.

Photographers have been packaging their works as gallery-style prints for some time, but most do not take

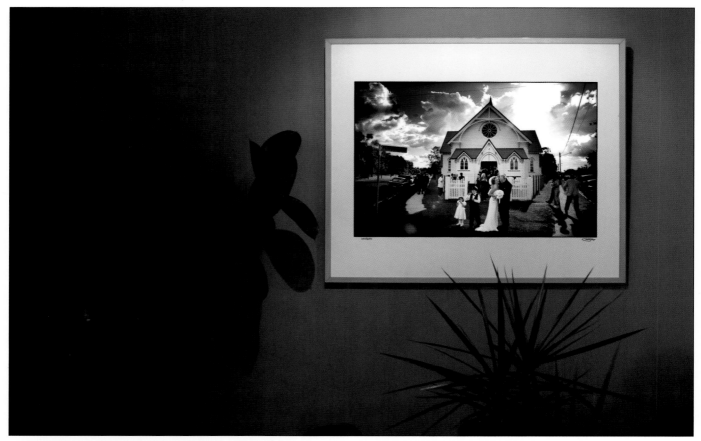

ABOVE—This frame shows the stylish beauty of the simplest of frames with a basic white mat. The frame and mat should never take away from the image they surround. LEFT—Signing and stamp embossing every print that leaves your gallery adds value and credibility to your work. It's important to produce the best possible quality in every product you produce. After all, it is your signature that will be on display in your client's home—both now and also in fifty years' time!

the presentation to the premium level, turning the prints into the prestigious and personal works of art that can truly be called collector's items. In order to sell the classic gallery print as a truly premium product, you must build a perceived value in the minds of your clients. This value must be tangible and true, or it will not sell— and it will negatively affect your reputation and reduce referrals.

There are a number of ways that you can elevate the perceived value of your prints in the eyes of your clients and improve the overall quality of the product itself.

First, a professional photographer should not consider using anything other than conservation framing and mounting to protect the longevity of the print. The use of UV glass and an acid-free archival mat also helps to prevent the degradation of the print, allowing maximum longevity.

Another important aspect of the classic gallery print is the frame. Simplicity and design are key elements; the frame should not overpower the image but provide an unobtrusive method of viewing. A simple box frame in a subdued color (like black, brown, beech, and silver) is best. Modern décor changes frequently, so elegant, timeless framing is necessary to ensure your clients do not need to redress their choice in the future.

To complement the frame, mat choice is crucial. In fine-art presentations, it is very rare to see mats in any

color other than white. Ensure that the mat you select is of premium, acid-free, archival-quality material to improve the longevity of your images.

When you purchase a gallery print from a landscape photographer, the image will be signed with a brief description and stamped with an embossed seal for authenticity. There is no reason your wedding images cannot be treated in the same manner. The images that a client will display on their wall are works of art; they are of great value and should be treated as such. Sign your prints on the front and write a brief description and date on the back. Follow this up by stamping the print with an embossed seal for authenticity and added presentation. It is these small details that make all of the difference.

While numbering prints in editions is nothing new, numbering *each print you ever produce* (as a photographer or as a studio) will, for most people, be a new concept. This approach offers many advantages. First, it enables you to keep a record of all the work you have ever produced. Additionally, registering a image within your collection as an original of the artist not only increases its perceived value, but it could also assist in the future when your individual images are appreciated as part of your total body of work. (Registering isn't just for your prints, either—you can register *all* your premium products such as albums, canvas prints, and limited-edition art books.)

Canvas Prints. Canvas has a feel all its own. Not every image is suited to canvas, but the images that *are* will truly come to life when they are displayed on this medium.

Finally, canvas gives us a way to present photographic art that looks fabulous in large sizes. There is no end to the way your clients can display canvas art in their home.

When it comes to large presentations, canvas images generally look better than prints. On average, you will find that your customers would prefer to own a 30x40-inch canvas than a photographic print of the same size. Canvas images are regarded as art and, as such, their perceived value is much greater.

Until I introduced canvas to my studio, I had always felt that a photographic print looked its best in the 7x10- to 20x24-inch range. This is the size of prints I was accustomed to seeing in galleries that display fine photographic prints. Because of my perceptions, I would seldom sell a larger print to a client. Adding canvas prints to my product line allowed me to sell larger images to my clients without skimping on quality. The number-one rule to selling a product is that you have to

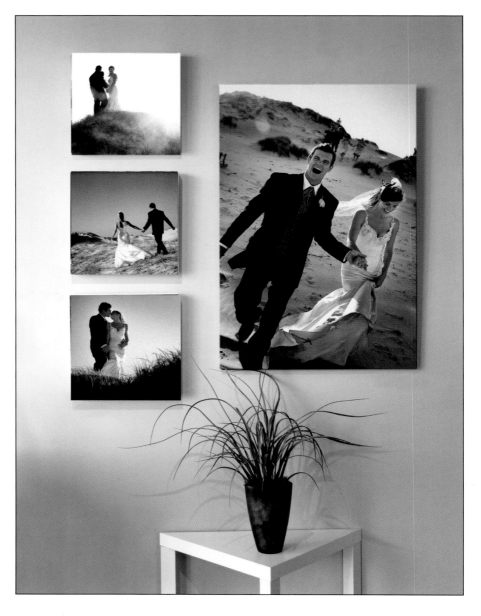

TOP—This canvas image shows more than just the bride and groom. Because the landscape is included, the client will feel far more comfortable displaying a large canvas than if the image was simply them and nothing else. BOTTOM—Combining canvas prints and framed prints can create a great feature for your client's home.

I have found environmental portraits, which depict more than just the subjects themselves, tend to sell well as canvas prints. In these images, there is an area of space that complements the subject and allows the eye to wander around the frame, exploring the image and how the subject is portrayed.

To make the most of your canvas prints, sign each one on the front, then add a brief description and date on the back. Stamp the side of your canvas with a embossing seal for authenticity and added presentation. Assign each canvas its own identifying number and register the print within your collection as an original canvas print of the artist.

Portfolio Collections. Clients often have limited wall space, already possess an amazing collection of art, or simply prefer their prints unframed. At Studio Impressions, we established our gallery collection a few years ago, providing our clients the opportunity to own premium unframed prints. We provide a few options for clients to view and present their works. We also have a range of storing options for safekeeping. This has inspired our clients to continue collecting additional photographic works through our studio and galleries.

The collection starts with the client's preferences, but there are two main options.

First, the prints can be mounted onto a board with a mat (typically 11x14 inches)—just like a gallery print

believe in what you are selling. I believe in canvas—how it is presented, how it looks, and how it feels—and my clients pick up on this. This has resulted in canvas becoming our biggest-selling product with engagement portraits. Canvas opened a whole new door for me: it made me sell big.

but without the frame. With this presentation, a clear piece of removable plastic is inserted between the print and the mat for added protection. A presentation case is also handcrafted to store the prints.

The second option is to have the image printed on a much larger piece of paper, usually a 13x9-inch image printed on 20x16-inch watercolor stock. This is a more stylish option and includes a leather box that will outlast the box provided in the first option.

In either case, each print is individually signed and registered. Often, people collecting twenty images at a time opt for specially designed frames to present their favorite image(s). This gives them the ability to present

a selection of images on their wall and to change their collection themselves.

Everything from your studio's presentation and customer service to the methods that you use to present your images to your clients will impact how they view you and your studio. It is not enough to be a great photographer, so keep on top of how you treat your clients and what your presentation is saying about you.

RIGHT—This is a fantastic option that allows the client to quickly change images whenever they choose. The small box means the images can be easily stored or presented on a wall in a series of 11x14-inch frames. BELOW—This is a more stylish option with a leather box that will outlast that in the first option. These prints are available in a 16x20-inch or 20x24-inch mat size. The clients are also able to hang these in frames and alternate the image from time to time.

8. ALBUMS AND ART BOOKS

The wedding album is one of the final products your clients will take home from your studio, and it will encompass the entire experience of their wedding and working with you. A great album design can mean the difference between a good photographer and a great photographer, an ordinary studio and a successful studio, a happy client and a client who will love you forever.

I have always strived to exceed my client's expectations. If you take this approach to every album design and regard each album as a unique story rather than a strict formula, you will create a work of art through your album design.

IMAGE SELECTION

Prior to the wedding day, we schedule two appointments with the couple. By booking these appointments in advance we ensure the quickest possible album production time for our clients.

The first meeting is for the couple to see their photographs in a slideshow and make an intial selection of images for their album. After the slideshow, the couple can choose to make their image selections on either a 100-inch projector screen in our viewing room or a 32-inch LCD screen in our sunroom.

They are given as much time as they want to make this initial image selection, and we remind them to try to select photographs that tell the story of the day. We

A beautifully presented, bound book with large thumbnails of numbered images allows the clients to share their images with friends and family. The book goes out once the client has completed their album selection (either in the studio or on-line) and not before.

direct their attention to any images we feel are particularly special.

At the conclusion of this session, we ask the clients' permission to design a draft album that tells the story of their wedding using both the images they have selected and any additional images we feel are important to the narrative. We advise them that this process is free of charge and that they will be able to select the pages that they feel best tell the story. We have found that showing the clients the best album you can possibly design helps them to make an informed decision on what they want their final album to look like.

The second appointment is to view the draft album design. This is usally ready about two days after the first appointment. At this meeting, the couple will decide on the final number of sides in the album.

DESIGN PRINCIPLES

When it comes to album design, the old adage "rules are made to be broken" holds true. However, as with all art, you need to know the rules back to front before you attempt to break them. I refer to my design style as quite classic—just like the little black dress or a 1950s Porsche, my albums are designed never to go out of style. The result is a collection of images that will have enduring appeal.

Research. It would be wonderful if you could simply copy a master photographer's album or use professional software to design flawless albums. However, your wedding albums should be as different as the couples and weddings they depict. Yet, while each shoot is unique, the principals and rules for creating stunning albums will always stay true. Learning to design albums will simply require some research, practice, and inspiration.

Studying the works of great photographers of the 1950s, as well as the albums of family and friends created during this time period, helped me to form the basis of my own album style—and it can do the same for you. The albums from this era often featured primarily pages with a single image to a page, then some groupings of images to tell the full story—just like a *Time Life* pictorial. Understanding how these designers used composition techniques when compiling their albums will allow you to apply these principals to your own designs.

Composition. When it comes to album design, you need to consider the composition of the individual

Often, clients can give us great ideas. One couple mentioned that they had a coffee table built to display their album rather than hiding it in a cupboard. The table was designed with UV glass. The album, which is viewed through the glass, sits in a drawer that enables easy access. This allows the couple to turn the page every so often and have a new look. They remarked on what a conversation piece the album has become. This has inspired many of our other clients and has become a recommendation of the studio on how best to display an album.

photographs as well as the composition that is formed when multiple images are combined on one page (or on a two-page spread, in the case of some albums).

As discussed above, when you create a photograph, the most important elements of the story should be highlighted, while the less important parts of the image can be allowed to recede into the background. The same techniques apply to album design. When planning a page or series of pages the most important element of the story must be highlighted. You need to be aware of the message you want to create on each page, with a combination of pages, and also from beginning to end. There are many different ways to achieve this.

Image selection and organization is the first step. Too often I've seen albums with eight images on a page that send eight different messages. Positioning the images sequentially and then grouping them according to themes (cutting the cake, guests dancing, etc.) within that timeline can prevent this problem.

Once you've decided which images will be grouped on a page, you'll need to make the leap from looking at individual images to dealing with the composition as a whole. Fortunately, the rules are the same as those discussed in chapter 3. For example, you'll want to look at what, in the group of images first attracts your attention and how your eyes travel around the page. Look for lines

and balance that can help to direct your eye. If the current arrangement doesn't seem to be working, move the images around and reevaluate the composition.

It is amazing how a simple design can actually be so complicated to produce—and how many different variables are involved. When the album works, however, the rewards are great. The clients' emotions will ebb and flow as they turn the pages—they will be propelled back to their wedding day to relive each moment. Even strangers will be able to discern the story of the couple's day and come away with an idea of what they mean to each other and what is important to them.

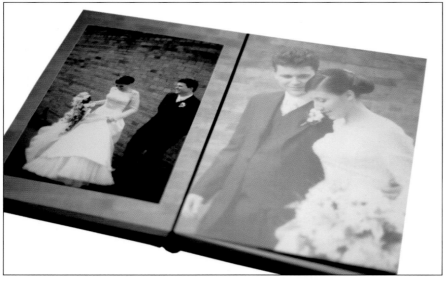

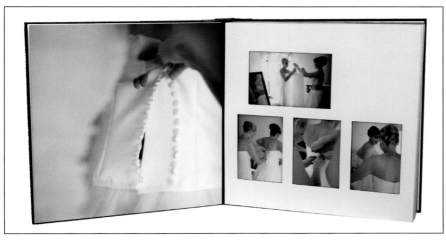

TYPES OF ALBUMS

For my album collections, I generally use four different formats, one of which is typically chosen by my client based on their personal tastes.

Classic Albums. Classic albums, featuring matted pages with beveled openings for each image, constitute approximately 20 percent of album sales at our studio. Clients tend to choose this style in the 13x13-inch square size. Most are designed with white pages and a black beveled edge on the mat (or a two-mat bevel, white with black), although occasionally a customer will ask for black pages. The mat is fitted edge to edge on a page to form a flush-matted book. I find the beveled edge helps to define the image on the page.

Magazine Albums. This album is often referred to as a coffee-table book. Generally thinner than a traditional album, it can appeal to space-conscious couples or couples who prefer a more modern look. It features full digital pages. These may either

TOP—Simple and classic, the traditional beveled edge album is a beautiful way to present your client's images. CENTER—The contemporary look of the magazine album or coffee-table book features a full digital page, or the pages can be inserted into a fully bound book. This is a popular alternative to the more traditional albums. BOTTOM—The combination album is the highest selling album at Studio Impressions. Clients can have the best of both worlds, with classic beveled-edge pages combined with contemporary digital pages that run to the edge.

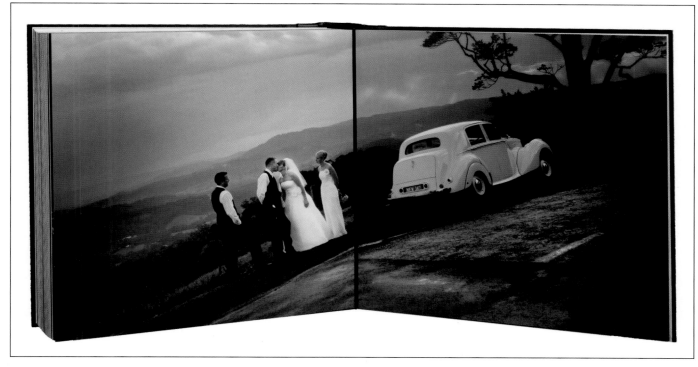

The classic panoramic image is a must in a wedding album. There are some images that lend themselves to this format and they are a very popular addition to the albums I design.

run edge to edge and be bound, or the pages can be inserted into a mat in a fully bound book. Around 20 percent of our clients choose a magazine album, and most prefer the edge-to-edge pages. While we do take advantage of the creative opportunities presented by full edge-to-edge pages, our magazine albums still maintain the same overall design principals of the more classic style.

Combination Albums. By far the most popular album is the combination album, a style that mixes aspects of the traditional and magazine album styles and, therefore, allows a client to have the best of both worlds. Approximately 60 percent of my clients choose this option.

A common inclusion in this design is the panoramic pages. On these pages, wide-format prints extend from edge to edge across two pages. This is fantastic for location shots, large guest shots outside the church, or any image that contains an element of grandeur.

Art Book Collections. An art book collection is an album printed on specialized, double-sided papers and bound to form a book. This can be used as an addition or alternative to the album collection.

I came across the concept of an art book while exploring ways to collect my favorite landscape images in a book or portfolio. At the time, there were no companies or set procedures to produce your own book, so the only option I had was to do it all myself. Forced to explore the possibilities, I was ultimately able to create a new product to offer to our clients. This opened up a whole new world of possibilities with great marketing potential—all because I wanted to look for something new.

For the first book, each page was individually printed on an Epson printer using Arches paper with torn edges. Each sheet was then creased so that the pages would turn easily and the book was simply bound with a cover. The book had a lovely feel.

Versions have progressed along the way and we are now able to offer a range of alternatives for clients to produce a one-off book. One of the biggest advancements was when Innova released their double-sided watercolor papers, which have a nice weighted feel. As it is double sided, this paper enables us to produce an oversized book (12x10 inches) using stitch-binding methods with a leather cover. Alternately, we can use the full oversized sheets (24x10 inches) and alternative binding methods to produce these individual books with a leather cover or a cover of the client's choice. Each book is embossed, stamped, signed, and numbered as an

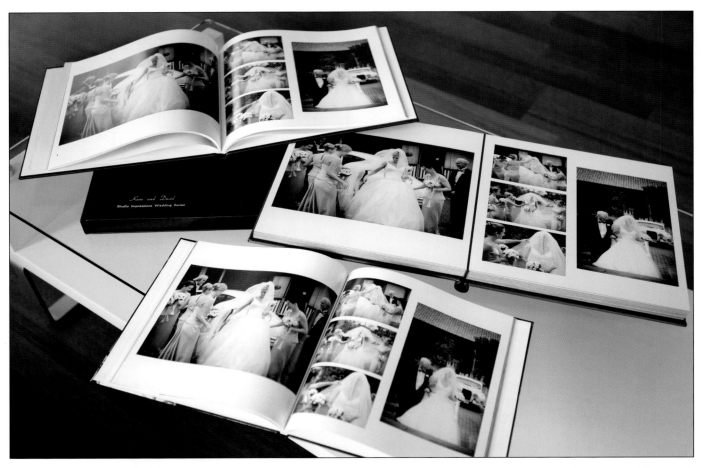

ABOVE—Clients can also purchase a collection of different albums. Pictured is a magazine album, an art book, and a professionally printed album like those offered by Asukabook and Graphi Studio (see below). All three variations complement each other. LEFT—Self-producing an art book printed on double-sided watercolor or luster papers from Innova can be time consuming and more expensive than creating a single-sided magazine album, but the results are far superior and the book becomes a unique album for the client.

authentic book by Studio Impressions. This has resulted in an amazing response from our clients.

These art books were such a success that we soon had many requests, particularly from our portrait clients, to purchase additional copies and to provide cheaper alternatives. As a result, we began to search for an alternative product. Our mission was to find a product that could be produced as a single copy (or in a very limited number) but still had the professionally published book "look." At first the task seemed destined for failure. But

finally, a friend (working with a helpful offset printer) perfected the art of this process. This enabled us to start offering our clients this new product a few years ago.

Again technology progressed. Two companies emerged: a Japanese company, Asukabook, and an Italian company, Graphi Studio. They found out exactly what we were trying to achieve for our clients and worked with us to produce a superior book product. Today, we are using a second generation of that idea with perfect precision. We are able to produce single-copy books that are just as good if not better than those made by a plate publishing company. One of the main reasons for their superior quality is their color management implementation.

There are many wonderful marketing opportunities to use with art books. For example, we invite previous wedding clients to be involved in a portrait session with the opportunity to have their own book produced of their family.

You can also produce books for your previous wedding clients that include their engagement and wedding shoots as well as pictures of the family they may have had taken since the wedding. You might even take a family-oriented approach, including other images taken throughout their lives by the clients themselves—including other family members and portraits of extended family.

Additionally, you may wish to invite people to become a part of a photograph-

These art books are a classy way for clients to display their wedding images—and a very mobile option for taking their images around to family and friends without carrying their large album.

er's book series, a book of images used in exhibitions or specialized books about babies, children, and pets.

WHAT DOES A GREAT ALBUM MEAN?

A great album design can mean the difference between a client only dusting off their album once a year to

begrudgingly show it to friends and family and loving it so much that they cannot wait to showcase it—they may even sit down a few times a year to remember the occasion. A beautifully designed album will often sit in a prominent position in the couple's house as opposed to being relegated to the storage cupboard.

In short, a great album becomes an heirloom that can be handed down through generations. It will teach great-grandchildren things about their great-grandparents that they would never have known otherwise.

With so much at stake, it is important to create outstanding albums—and there's a direct relationship between great design and how much your clients will like their album (and how enthusiastic they will be about purchasing additional pages for it). Many bookings come directly from word of mouth and from couples seeing your work through friends and family, so design each album as though it were a showcase piece to be displayed in in your studio.

ABOVE—Creating each book you produce as an individually numbered limited edition adds value to your product. It is also important to sign every book; your signature is important to your client and increases the album's perceived value. **PAGES 109 THROUGH 112**—This album design tells the full story of the day. It does not include every image taken on the day, but it does capture the key relationships, the mood and feel of the day, and the love between the couple.

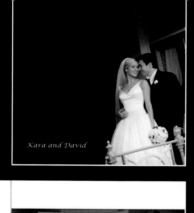
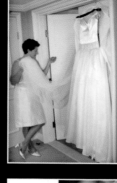

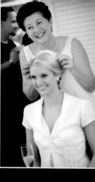

Kara and David

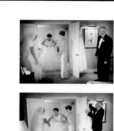
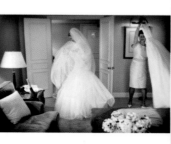

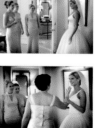

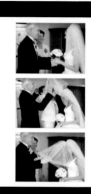
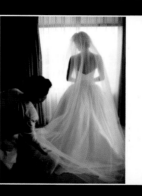

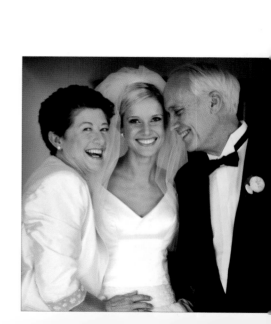

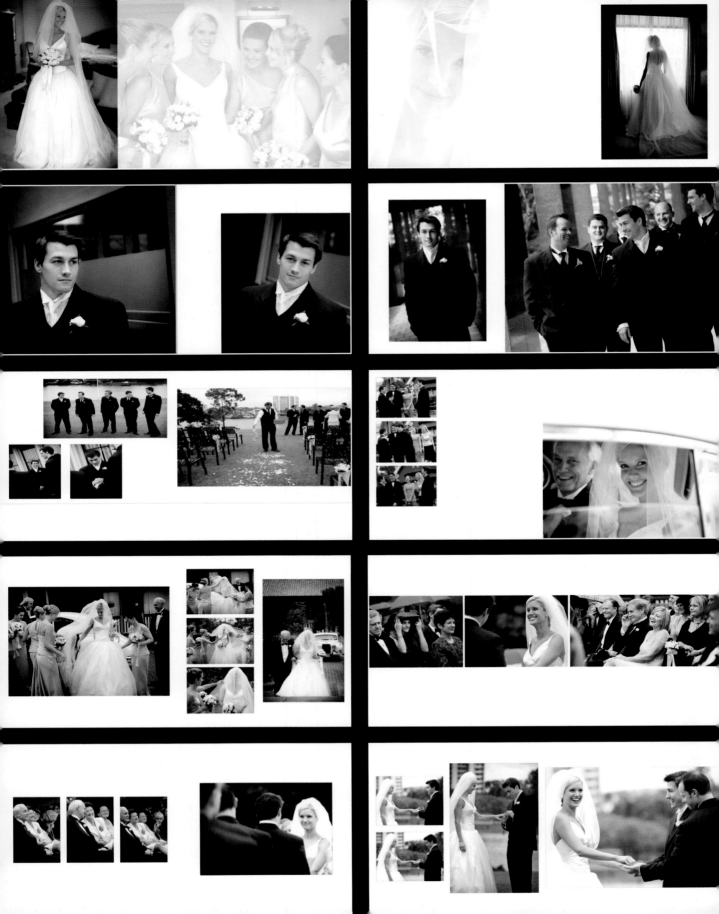

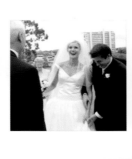
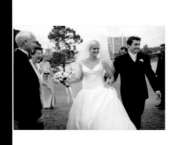

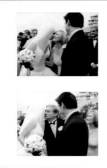

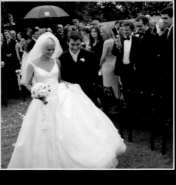

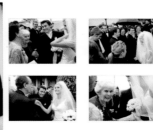
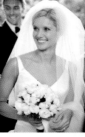
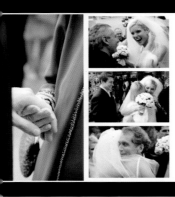
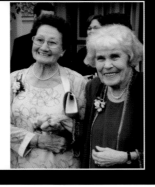
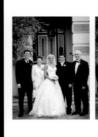

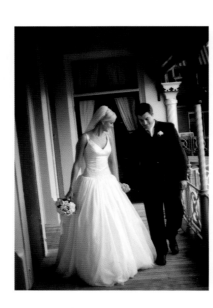
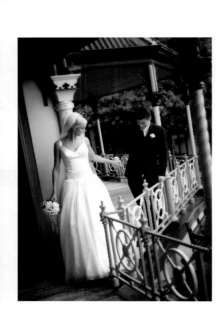
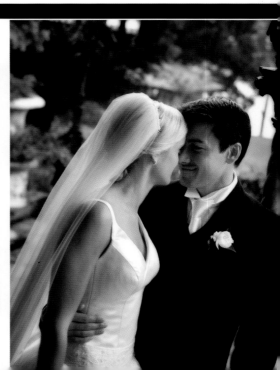

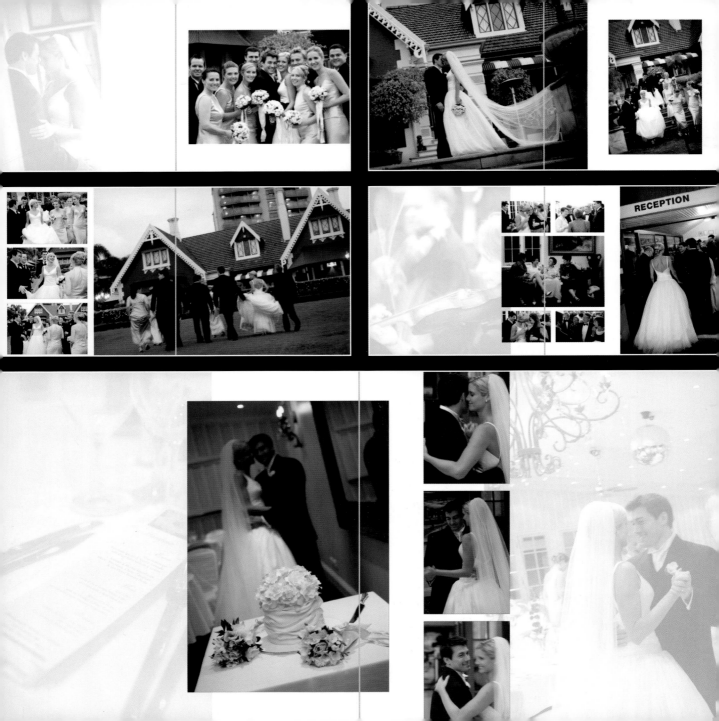

9. EQUIPMENT AND WORKFLOW

While creativity is critical to success for a professional photographer, there are other factors that will prove just as important. These include the equipment you use (both to shoot your images and to enhance, print, and present them) and the methods you use to work with your image files during and after the shoot (i.e., your digital workflow). Only when these factors are managed carefully can your business truly thrive.

EQUIPMENT

To produce a perfect wedding image requires equipment that is up to the task. That includes both the equipment used to shoot the image and the software, hardware, and other materials used to process, print, and present the image after the shoot. Equally important is taking the time you need to truly master your equipment. The less time you spend fiddling with your gear, the more time you have to shoot incredible images.

Budget. When it comes to equipment, it is important to make calculated risks and invest in your business as it continues to grow.

I value my photography, so I use the best equipment I can afford. When I first started out in my career I could never afford the gear I have today. It was a slow progress of gradually upgrading as I went along. Of course, this didn't mean I couldn't capture and create great images back when I started out; quality is important, but it's not the gear that makes the image, it's you.

When selecting equipment, it's wise to determine your budget based on your total income. For example, if you are shooting fifty weddings a year at an average of

When you are shooting a wedding, you need to be able to move quickly and unobtrusively. You should never miss a shot because you are busy scrambling with camera gear, so have everything you need within easy reach and ready to use. I carry a minimum of gear with me when shooting—usually two camera bodies and a waist bag that contains all the extra bits and pieces I may need. I find Tamrac bags to be the easiest to access, while still keeping your gear secure as you shoot. I keep my bodies and on-the-go hip bag in a Tamrac camera roller bag; it's the perfect carry-on when travelling.

$3000 each, you might consider purchasing the Canon 1D Mark II. However, if you are shooting ten weddings a year at an average of $1000, you might consider using the Canon 30D or 5D until your number of weddings (or dollar average per wedding) increases. It is important, however, that once they do increase, you make the next equipment upgrade. Otherwise you will be doing yourself and your clients a disservice.

The same concept holds true when selecting computer hardware and software. Purchasing the best you can afford (and learning how to use it efficiently) will free up valuable time to market your services and grow your business.

Camera. The amount of equipment a photographer has to lug around with them is crucial, particularly if

This Canon 5D kit packs away very conveniently for ease of use and does not weigh me down.

they plan to shoot as a photojournalist for any length of time.

I recently changed my shooting style to incorporate two digital camera bodies, so that I could have various lenses at my disposal at any one time. The principle behind this change was to return to the way I originally started photographing weddings—back when I would photograph with color film on a Canon 1 series camera and black & white film on a Leica M series camera.

Now I predominantly use either two Canon 1DS Mark II bodies or two Canon 5D bodies. I use the 85mm 1.2L series lens and the 35mm 1.4L series lens religiously, but I also have the option of using one or both of the bodies with a zoom lens (24–70mm f2.8 or 70–200mm f2.8).

This really minimized the gear I have to carry. With my current setup I have everything that I could possibly need in my little waist bag. As a result, I don't look as imposing to the couples and guests, which is a significant advantage when working in the photojournalistic style.

Computer Hardware. When it comes to your computer system, you should seriously consider the time it takes for your conversions and actions to be performed. Put your business hat on and think about it: the more time you are spending in front of a computer, the less time you are spending on your business and marketing. If an employee is handling these computer tasks, a more efficient system can free up his or her time as well. This

LEFT—The only difference between this kit and the Canon 5D is the bodies. I shoot with two 1DS Mark IIs or two 5Ds at a wedding depending on the hours of coverage and how many weddings I will be shooting in a row. Time is a factor because the 1D kit is much heavier than the 5D kit. There is also a big difference in functionality. The 5D is not a professional photographer's camera really, but it performs well. While I frequently choose the 5D for long weddings, my camera of choice is generally the 1DS Mark II, as it offers everything a photographer needs. The only disadvantage is the weight, which can sometimes prohibit some images being taken successfully on a long shoot. Another important choice is your removable media. I use only SanDisk cards, which I find to be reliable, fast, and durable. RIGHT—This kit packs up very conveniently, as shown.

It is vital for a professional photographer to carry a backup kit, and mine consists of two 5D or IDS Mark II bodies, which fit into this bag. The backup kit stays in my car and contains various lenses I might need, a backup camera (a 1D Mark II), a 550 EX flash, a large flash, and some extras like spare memory cards and the charging equipment for my batteries.

means you'll have more help on projects like providing images to a reception venue. The money you invest in acquiring a faster system, therefore, can often be quickly recouped.

Where monitors are concerned, the better your monitor, the better you will be able to view your images—it is as simple as that. Spending a little more on a monitor can make a huge difference to the output of your prints. It is also critical that your monitor be properly calibrated (we use the X-Rite color monitor calibrator); this ensures the accuracy of what you are seeing on screen—a necessity for every professional photographer. Additionally, you should view your images in an uncluttered environment with consistent lighting (and preferably dim lighting).

CAMERA SHAKE

I never use a tripod and have not for a number of years. This can lead to shaky images—especially with slower shutter speeds. Therefore, I suggest looking for places where you can support yourself and camera to reduce camera shake. Hold the camera close to your face and bring your arms in close to your body to give it as much support as possible. Take two or three images at a time and hold your breath while doing so; at least one of the images will usually be sharp. An advantage of this method is that I can capture more images in environments where I need to be less intrusive.

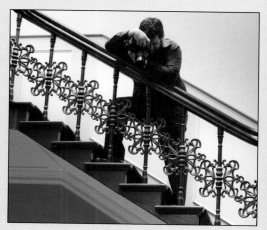

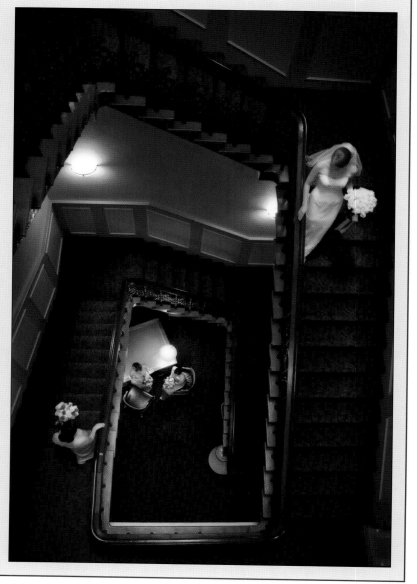

In the image above I am using the banister as my support. My legs are firmly positioned apart to provide as much stability as possible and using the banister reduces any shaking. The image to the right is the result of this shoot. It was shot at 1/8 second, which shows you it is possible to work without a tripod.

 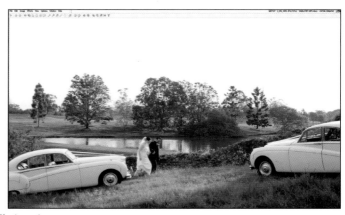

CompuPic makes it easy to edit through an entire wedding with full-size views.

Breeze Browser is the program we prefer for editing images from engagement and wedding shoots.

It is also fantastic to have a high-end, professional-quality printer to output your proofs, album prints, and fine-art prints on photo luster papers, watercolor papers, or even canvas.

Software. I believe all photographers should work with the latest versions of Photoshop, Capture One, CompuPic Pro (or a similar program), and a good real-time RAW viewer like BreezeBrowser.

CompuPic Pro is a great program for viewing images and renaming files. In my experience, it is the fastest program for previewing high-resolution JPEG files. Another great feature is that we can actually quickly downsize images using a batch process conversion to produce a slideshow at a reception. Compupic Pro does not read the EXIF data to automatically rotate images, but this can be compensated for by using a program like Downloader Pro, which enables images to be rotated while being downloaded. This will give your workflow a boost. To quickly produce professional slideshows, you can't do better than Photodex Producer.

Breeze Browser is the program we prefer for editing images from engagement and wedding shoots. It is the fastest program for previewing RAW images and conveniently combines RAW and JPEG files for viewing. It will also delete both at the same time, which is a great time saver when editing in preparation for the couple's viewing session.

DIGITAL WORKFLOW

In today's photography environment, implementing an efficient digital workflow is just as important to building a successful business as your marketing and sales strategies. It is a huge area that over the next few years will shape how photographers work, think, and use their images. Workflow has a large influence on profits, so photographers who don't stay up to date and efficient will quickly be outpaced by studios that take this aspect of their business seriously.

Developing the workflow that is right for you and your studio involves setting your priorities. This will

help guide you in making the right decisions. In each case, however, expect there to be some tradeoffs—especially as you get started. If you're striving for the ultimate in quality as well as the fastest possible workflow, you must anticipate higher setup and operating costs. However, these could be offset by an increase in efficiency, the ability to spend more time providing top-notch customer service, and ultimately an increase in the number of clients who seek out your high-end services. At the other end of the spectrum, a low-cost, low-qual-ity solution could see initial cost savings. However, it may also result in a long-tern business decline if your competition outshines you by providing better customer service and a far superior product.

As the saying goes, "Rome wasn't built in a day." Just so, workflows will also be determined by our own current limitations (i.e., your current expertise and financial position). If, for example, you're just starting out in your business and try to immediately implement the ultimate in workflow solutions without thoroughly

Do you want your prints to be rated as world-class masterpieces or just provide a quality that is on par with professional standards?

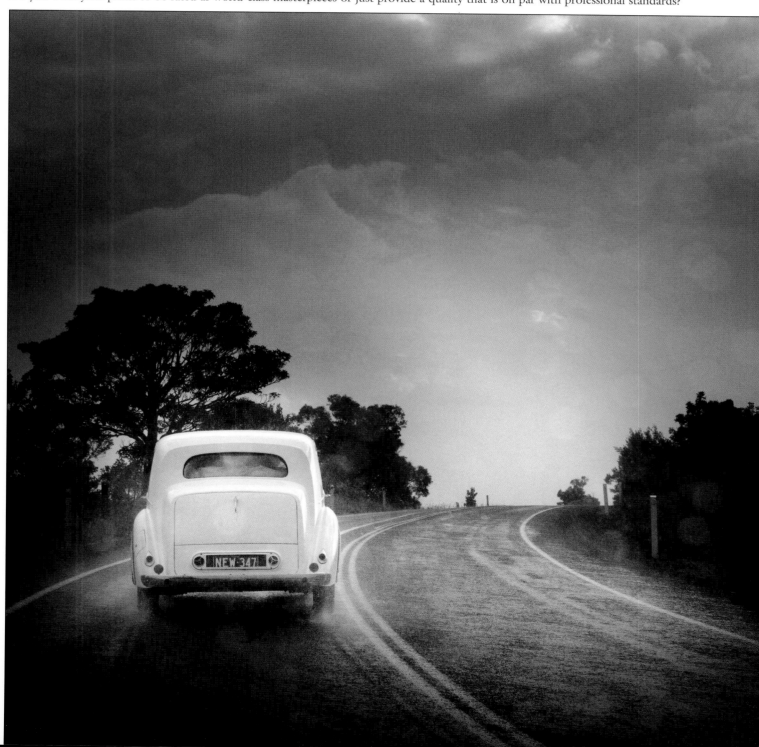

COLOR MANAGEMENT

Understanding color management and profiling has become an art form in itself. Often, what we envision as photographers—and what we see on our computer screens—is not what we actually see in our prints. A good color management protocol can be extremely helpful in ensuring predictable, consistent results. If you are not well versed in color management, working with a color technician can be quite valuable as you are developing a customized workflow.

Keep in mind however, that even a "technically correct" print (one that portrays the true color value and renders the full range of the available gamut within the limitations of the paper) may fail to portray the feeling that the photographer had in mind. Sometimes, for example, a photographer may not want to have detail in the entire print; he or she may clip information to produce a more contrasty, lively print, or perhaps give more detail in the whites and therefore purposely throwing away information in the blacks. Sometimes it's about the feel, not just utilizing every possible shade between pure black and pure white.

As you can see, color management can be quite subjective. With some effort and good technical know-how (or advice), however, achieving consistent, pleasing color is definitely achievable and well worth the effort.

to be rated as world-class masterpieces or just provide a quality that is on par with professional standards? Answering these questions involves looking at all of the elements in your business that affect quality—from capture to output. This could include the quality of your lenses, the format of capture (RAW or JPEG), whether you use an 8-bit or 16-bit workflow, your color management practices, the resolution of your print output, the paper stock you use, and much more.

Time Management. Do you need the fastest workflow money can buy? Do you want to have a life outside the studio? Having a workflow that dramatically reduces the time you spend on production will typically require greater startup costs, but it will ultimately save the business money and allow you to provide better service to your clients.

Another important factor when assessing time management is lifestyle. One of the biggest concerns to the modern photographer is the amount of extra time spent working at the computer. Instead of just dropping your film off at the lab on Monday, when today's wedding photographer returns home from a long shoot he or she can anticipate spending several hours downloading

thinking about the financial commitment, the result can be disastrous. We are all at different stages in our careers, and our varying investments into our workflow solutions should be gauged accordingly.

Ultimately, there are four key workflow elements to consider. These are detailed below.

Quality. What do you want to provide to your clients as far as quality is concerned? Do you want your prints

Sometimes it's about the feel, not just utilizing every possible shade between pure black and pure white.

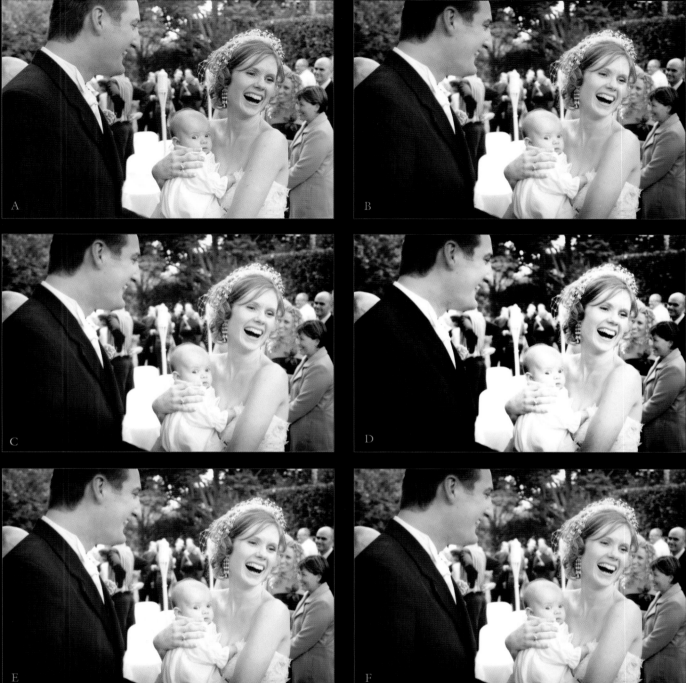

Using actions, your images can be quickly processed to create a variety of effects. Here we see the original camera file (A), the corrected studio master image (B), the studio black & white image (C), the cross-processed image (D), the sepia image (E), a version that combines sepia and color (F), and a blue-toned image (G).

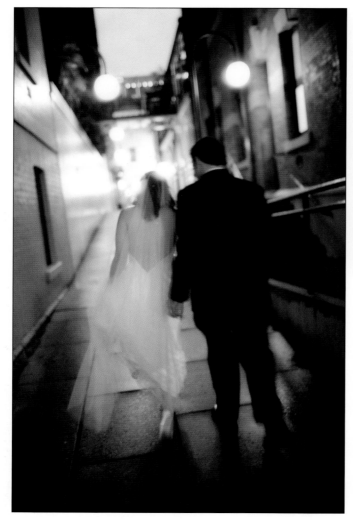

LEFT—If a strict protocol is adhered to and quality equipment is used, you can feel assured that you will never lose a single image. ABOVE—By preparing all of your CF cards before the shoot, you can avoid having to stop to format cards during the shoot—something that can cost you precious photo opportunities.

(or if finding them takes hours!). Again, a clear, consistently implemented protocol is important.

SAMPLE DIGITAL WORKFLOW

The best way to ensure success is to develop a photographic protocol that takes you all the way through the process of creating images. Once you've established the procedures you want to use, live by them. Eventually, these steps will just become second nature.

Each photographer will develop a workflow that is fine-tuned to his or her needs. The following steps, however, provide a basic overview and show you some of the factors that need to be considered.

Image Capture. Before each shoot, ensure that the previous data on your memory cards has been backed up, then format all of your CF cards in the camera (never merely erase images; this can leave behind fragmentary data that can later cause disc errors). This ensures that you will never need to stop shooting in order to format a card during the event. Because you'll never be forced to format a card on the fly during an event, you will also avoid the potential for accidentally formatting a card that you have already used. Obviously, using this system also means that you must have more than enough CF cards to capture the entire event.

Before every shoot, check your camera settings to ensure you are shooting at the intended image size and

images and backing up memory cards instead of spending time with their family.

Cost Management. Are you looking for the cheapest solution? Adding equipment, staff, and resources will all increase the cost of doing business. These additional expenses can be quite high, so it will be important to do careful cost comparisons when you consider increasing expenditures to increase your productivity. You'll need to weigh affordability, quality, and time efficiencies.

File Management. While film photographers have felt comfortable relying on a single source of protection (i.e., one set of negatives), file security and storage is a major concern to the digital photographer. If a strict protocol is adhered to and quality equipment is used, however, you can feel assured that you will never lose an image. Scrimping in this area will only cause headaches.

Another important aspect to image management is your image filing system; having the files available isn't of much use if you can't find the ones you're looking for

using the right file format, ISO, and white balance setting. You should also confirm that the image orientation setting is on; this provides greater ease of viewing and editing.

Always shoot RAW—and, if possible, shoot RAW plus JPEG (small). Shooting RAW plus JPEG will give you complete flexibility, allowing you to quickly use the JPEGs to prepare a slideshow at the reception or transmit an urgent image across the world. There have even been times when I have had to work with the JPEG images to produce a next-day presentation for clients who were leaving the country and needed to plan their album before departing.

Image Downloads. Download cards on the fly while shooting using a portable hard drive. For added security, keep the hard drive on your person at all times. Once downloaded, store the completed cards in your camera bag or another secure spot. Once this is done, you will have two copies of the data with you—in two different locations. Therefore, if your bag was ever stolen you would still have a copy of the valuable data. (And if you were to accidentally fall into the ocean, dousing the hard drive, you would have your CF cards safely in a bag in the car.)

Backing up your cards as you shoot will also save you some time when downloading your data after the event; you'll be able to transfer the images to your main computer en masse from the portable hard drive rather than having to access each card individually. You should *immediately* back up the data from this portable drive once the shoot is complete.

If you want to avoid having to return to your studio after the event, invest in a computer for your home and use this to back up your data to CD or DVD (using premium media). These will be your master discs, containing the original, unedited captures from the event.

Before reusing your CF cards, ensure that the files are completely backed up to your main computer and that you have a set of secure download discs. It is also preferable to keep the data on your portable hard drive until the images have completed the entire workflow process.

Image Editing. Once you have downloaded and backed up your images, the files can be put into one directory or folder. If the images were shot with multiple cameras, you may need to ensure that file names are not duplicated.

When viewing images, it is helpful to sort them by the time of capture. This lets you instantly create an organized timeline of events. Next, I like to use Breeze Browser to view, select, or delete the RAW images, but you can also use other programs like Photoshop, Capture One, ThumbsPlus, ACDsee, or Aperture.

The goal at this point should be to reduce the number of images into a manageable number from which the clients can select their favorites. As a professional, you should only show your edited images. You never see a painter's misses, and there's no need to show yours. This is especially true with digital, since the tendency is to shoot more. As a result, we often push ourselves to the limit—and sometimes these experiments don't quite work out. Therefore, in addition to blinks and misfires, you should eliminate any image that doesn't live up to your standards—while, of course, still maintaining the images needed to tell the complete story of the day. This process doesn't just make it easier for your clients to

Attention to detail can help you capture every memorable moment that goes into a wedding day.

 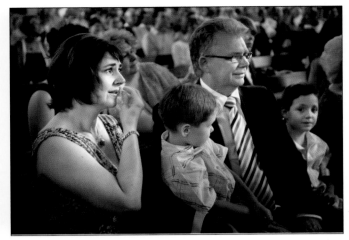

The client will almost certainly select the image on the right, but they would have skipped over the image on the left, missing the dramatic emotion

select images, it's also a powerful tool for you, giving you a chance to review the entire shoot and learn from what worked and what didn't. Learning to edit your images is one of the most important skills you can develop as a photographer.

Once you've done this edit of the files, you can create a studio master disc containing the selected files. This is the disc from which files should be retrieved as needed. Once this disc is created, the master download discs (the discs containing all the original files) should not be stored at the studio. This provides additional security in the event that the studio is destroyed by fire or some other disaster.

Image Processing. The next stage in a semiautomated workflow involves sorting the images into processing folders. Each folder represents a particular exposure compensation (if required) and image effect (i.e., black & white, color, blue tone, or sepia). For each folder, an action is then used to correct the exposure and apply the desired image effect. For instance, if the folder contains images that are one-stop underexposed and need to be converted to black & white, then the action contains a black & white conversion action plus a Levels adjustment that produces a one-stop exposure increase. Additional actions can then also be applied to produce any additional effects you like (sharpening, vignetting, selective blurring, color tweaking, etc.). Finally, actions can be used again on these folders to prepare copies of the images according to their intended uses.

I have found it extremely valuable to show wedding clients only fully processed images at the first viewing, rather than images straight out of the camera. We find that this practice makes a significant difference in the amount of images the clients select for their album.

For example, the image on the left (above) shows the moment as it was shot. The image on the right (above) is the final image the clients will see at their first viewing. The difference is that the client will almost certainly select the image on the right, but they would have skipped over the image on the left, missing the dramatic emotion that was revealed through master printing.

Creating a highly efficient workflow is critical to this process—after all, you don't want to spend weeks processing the images from one wedding! Over the past eight years we have perfected our workflow so that we are now able to process over *eight hundred* images in a matter of two hours.

IN CLOSING

As you can see, there are a number of technical and practical considerations that must be carefully considered when selecting equipment and developing a workflow. Attention to detail in these areas, however, can help you to achieve your greatest potential—both creatively and professionally.

W hat is not to love about being a professional photographer? There is so much power and responsibility in our work. We capture a moment in time, and in that instant we encapsulate an entire story—the emotion, the movement, the energy, the *life*. We have the ability to capture memories that will last forever. There are not many jobs that allow you to do something that is so special. You should feel proud and honored that photography is your profession.

IN REVIEW

In writing this book, I have taken what I believe to be a unique approach to the process of wedding photography. Rather than just concentrating on two or three aspects of producing a great image, I have added many of the aspects that I use in my work to take a more holistic approach to the art.

We've looked, for example, at how the work of other artists—of all genres—can inspire your own work. We've also examined how being prepared and organized will build your confidence and allow you time to be creative. Additionally, we've looked at the importance of understanding your customers' needs and wants. Your clients have come to you because they love the part of you that they see in your images; it is what drew them to you in the first place. So, put a little of yourself in every image—and remember to be respectful and generous to the couple and guests during a wedding shoot.

We have also examined the need to offer outstanding customer service both before and after the wedding. Present your images in a way that reinforces your signa-

DEVELOPING RELATIONSHIPS

At Studio Impressions, we rely on the style and personality of the photographer, coupled with the great service and products we offer, to maintain our competitive edge in the photographic market. The business is marketed to the middle/upper end of the client market and strives to cater to the needs of this sector of the population.

Studio Impressions sets itself apart from its competitors by providing customer service that is superior to the current market standards. To accomplish this, we strive to establish a personal relationship with our customers. We want them to feel that they are inviting a friend to their wedding rather than hiring a photographer.

This sense of fun and enjoyment spills over into our portrait work. In both the commercial and fine-art markets, as well, the business strives to develop ongoing relationships with customers and to maximize repeat business opportunities. The focus is on developing relationships to understand and meet customers' photographic needs rather than simply "getting a job done."

ture style and wow your clients with the best products, printing techniques, and papers you can afford. Selling is usually a "cringe" activity for photographers, but if you approach it with the right attitude you can see it as a process of properly serving your clients instead of an attempt to line your own pockets. Provide professional, honest advice to your clients and let them make the monetary decisions. That way, sales will take care of themselves and you can take some of the pain out of a necessary part of your job.

Finally, we looked at the need to continue to be an interested photographer who actively explores the prod-

When my wife and I began our home renovations, a very important component was to make a haven away from our busy lives where we could dream together for our family and for our careers.

ucts and techniques available to them—and looks for ideas that others have not yet discovered. Keep on top of current trends and cutting-edge technology so that you can keep moving forward and providing your clients with the kind of service they deserve.

MOVING AHEAD

Wedding photography is constantly changing. As a result, when you are in the middle of juggling all the aspects of running a studio, it is easy to lose direction. The following tips may help you keep you on track and moving forward.

Establish the Right Mind-Set. Establishing the right mind-set—and continually reminding yourself to maintain it—is an important component to ongoing success as a professional photographer. The following are key components to establishing this mind-set:

1. Approach every shoot, and every obstacle, with a positive attitude.
2. Understand your own emotions and motivations so that you can utilize them in your photography.
3. Master artistic principles and apply them consistently in your photography so that they become second nature.
4. Understand the basics of photography and learn to use your equipment so well that it requires almost no conscious thought.

Find Your Space to Dream. It is also important to take some time out of the everyday routine of working at your studio to dream. Create a safe, comfortable, and relaxing place where you can take stock of your situation and dream of new possibilities.

If you do not have a place like this at home, creating one could be as simple as buying some candles, incense, and nice potted plants to produce a pleasant environment, or consider going away for a few days to recoup and think. Over the years, I have joined my wife's company on their strategic planning weekends. They rent out rooms at a quiet hinterland resort and work together, while I take the time to plan for my year ahead on my own. I reevaluate my strategic and business plans, work out the marketing opportunities for the year, and plan any major projects. Mostly, I just take some time to focus on Studio Impressions—some time to dream for my business.

Make Plans to Live Your Dreams. Take ownership of your destiny and stop to review your plans along the way. Make sure that you are still on the right path. Once you have developed a business and strategic plan that reflects your goals and dreams, ensure that it is integrated into the daily decisions you need to make.

IN CLOSING

For me, it is a privilege and a passion to photograph—to capture all the beautiful things in the world and share them with others, to evoke feeling and emotion and appreciation for the world we live in. This is why I do what I do, and this is why I work so hard to be successful at it. I hope you'll find the same joy and rewards in your own career as a professional photographer!

INDEX

DIGITAL PHOTOGRAPHY BOOT CAMP

Kevin Kubota

Kevin Kubota's popular workshop is now a book! A down-and-dirty, step-by-step course in building a professional photography workflow and creating digital images that sell! $34.95 list, 8.5x11, 128p, 250 color images, index, order no. 1809.

PROFESSIONAL POSING TECHNIQUES FOR WEDDING AND PORTRAIT PHOTOGRAPHERS

Norman Phillips

Master the techniques you need to pose subjects successfully—whether you are working with men, women, children, or groups. $34.95 list, 8.5x11, 128p, 260 color photos, index, order no. 1810.

PROFESSIONAL MARKETING & SELLING TECHNIQUES FOR DIGITAL WEDDING PHOTOGRAPHERS 2nd Ed.

Jeff Hawkins and Kathleen Hawkins

Taking great photos isn't enough to ensure success! Become a master marketer and salesperson with these easy techniques. $34.95 list, 8.5x11, 128p, 150 color photos, index, order no. 1815.

PROFESSIONAL PORTRAIT LIGHTING TECHNIQUES AND IMAGES FROM MASTER PHOTOGRAPHERS

Michelle Perkins

Get a behind-the-scenes look at the lighting techniques employed by the world's top portrait photographers. $34.95 list, 8.5x11, 128p, 200 color photos, index, order no. 2000.

MASTER POSING GUIDE FOR CHILDREN'S PORTRAIT PHOTOGRAPHY

Norman Phillips

Create perfect portraits of infants, tots, kids, and teens. Includes techniques for standing, sitting, and floor poses for boys and girls, individuals, and groups. $34.95 list, 8.5x11, 128p, 305 color images, order no. 1826.

WEDDING PHOTOGRAPHER'S HANDBOOK

Bill Hurter

Learn to produce images with technical proficiency and superb, unbridled artistry. Includes images and insights from top industry pros. $34.95 list, 8.5x11, 128p, 180 color photos, 10 screen shots, index, order no. 1827.

RANGEFINDER'S PROFESSIONAL PHOTOGRAPHY

edited by Bill Hurter

Editor Bill Hurter shares over one hundred "recipes" from *Rangefinder's* popular cookbook series, showing you how to shoot, pose, light, and edit fabulous images. $34.95 list, 8.5x11, 128p, 150 color photos, index, order no. 1828.

MASTER LIGHTING GUIDE FOR COMMERCIAL PHOTOGRAPHERS

Robert Morrissey

Use the tools and techniques pros rely on to land corporate clients. Includes diagrams, images, and techniques for a failsafe approach for shots that sell. $34.95 list, 8.5x11, 128p, 110 color photos, 125 diagrams, index, order no. 1833.

THE PHOTOGRAPHER'S GUIDE TO COLOR MANAGEMENT PROFESSIONAL TECHNIQUES FOR CONSISTENT RESULTS

Phil Nelson

Learn how to keep color consistent from device to device, ensuring greater efficiency and more accurate results. $34.95 list, 8.5x11, 128p, 175 color photos, index, order no. 1838.

SOFTBOX LIGHTING TECHNIQUES FOR PROFESSIONAL PHOTOGRAPHERS

Stephen A. Dantzig

Learn to use one of photography's most popular lighting devices to produce soft and flawless effects for portraits, product shots, and more. $34.95 list, 8.5x11, 128p, 260 color images, index, order no. 1839.

JEFF SMITH'S LIGHTING FOR OUTDOOR AND LOCATION PORTRAIT PHOTOGRAPHY

Learn how to use light throughout the day—indoors and out—and make location portraits a highly profitable venture for your studio. $34.95 list, 8.5x11, 128p, 170 color images, index, order no. 1841.

PROFESSIONAL PORTRAIT POSING

TECHNIQUES AND IMAGES FROM MASTER PHOTOGRAPHERS

Michelle Perkins

Learn how master photographers pose subjects to create unforgettable images. $34.95 list, 8.5x11, 128p, 175 color images, index, order no. 2002.

MONTE ZUCKER'S
PORTRAIT PHOTOGRAPHY HANDBOOK

Acclaimed portrait photographer Monte Zucker takes you behind the scenes and shows you how to create a "Monte Portrait." Covers techniques for both studio and location shoots. $34.95 list, 8.5x11, 128p, 200 color photos, index, order no. 1846.

THE BEST OF PHOTOGRAPHIC LIGHTING

2nd Ed.

Bill Hurter

Top pros reveal the secrets behind their studio, location, and outdoor lighting strategies. Packed with tips for portraits, still lifes, and more. $34.95 list, 8.5x11, 128p, 200 color photos, index, order no. 1849.

JEFF SMITH'S POSING TECHNIQUES FOR LOCATION PORTRAIT PHOTOGRAPHY

Use architectural and natural elements to support the pose, maximize the flow of the session, and create refined, artful poses for individual subjects and groups—indoors or out. $34.95 list, 8.5x11, 128p, 150 color photos, index, order no. 1851.

MASTER LIGHTING GUIDE

FOR WEDDING PHOTOGRAPHERS

Bill Hurter

Capture perfect lighting quickly and easily at the ceremony and reception—indoors and out. Includes tips from the pros for lighting individuals, couples, and groups. $34.95 list, 8.5x11, 128p, 200 color photos, index, order no. 1852.

THE BEST OF PORTRAIT PHOTOGRAPHY

2nd Ed.

Bill Hurter

View outstanding images from top pros and learn how they create their masterful classic and contemporary portraits. $34.95 list, 8.5x11, 128p, 180 color photos, index, order no. 1854.

THE ART OF PREGNANCY PHOTOGRAPHY

Jennifer George

Learn the essential posing, lighting, composition, business, and marketing skills you need to create stunning pregnancy portraits your clientele can't do without! $34.95 list, 8.5x11, 128p, 150 color photos, index, order no. 1855.

ILLUSTRATED DICTIONARY OF PHOTOGRAPHY

Barbara A. Lynch-Johnt & Michelle Perkins

Gain insight into camera and lighting equipment, accessories, technological advances, film and historic processes, famous photographers, artistic movements, and more with the concise descriptions in this illustrated book. $34.95 list, 8.5x11, 144p, 150 color images, index, order no. 1857.